PAINTING
LIGHT & SHADOW
IN WATERCOLOR

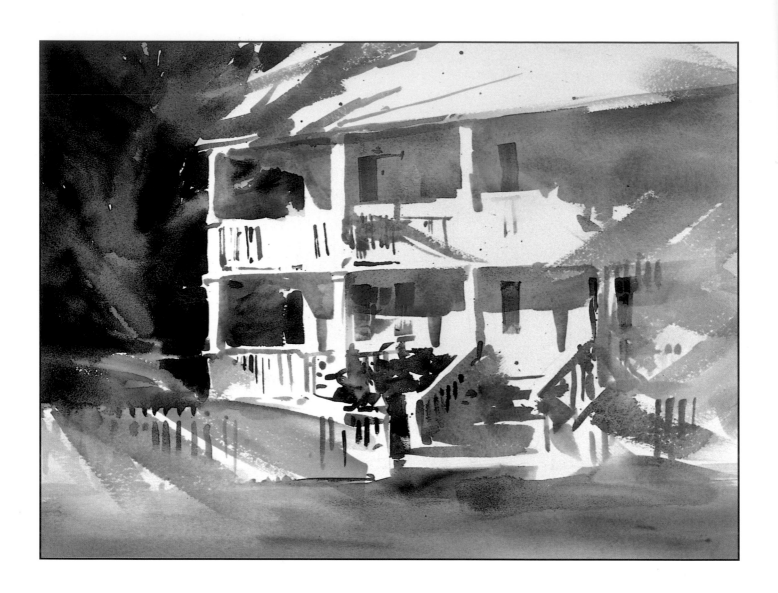

PAINTING
LIGHT & SHADOW
IN WATERCOLOR

Rembrandt thought it more important to paint light
than the objects that are seen by it.

Sir Joshua Reynolds, *Discourses*

SKIP LAWRENCE

NORTH LIGHT BOOKS

Cincinnati, Ohio

ABOUT THE AUTHOR

William B. (Skip) Lawrence resides in Mt. Airy, Maryland. He was born in Baltimore in 1943, received B.F.A. at the Maryland Institute College of Art, Baltimore, Maryland (1965) and an M.A. at Towson State University, Baltimore, Maryland (1971). From 1965 through 1972 he taught in Howard County, Maryland. After leaving the public school system to devote his time to painting, he was persuaded to teach part-time at Prince George's Community College, near Washington D.C. One evening watercolor class at his studio in Laurel, Maryland has grown to hundreds of national and international workshops since 1976, when he conducted his first workshop in Nags Head, NC. Today he conducts an average of 20 workshops annually. Summers are reserved for Maine and some painting time coupled with his popular summer workshops.

Skip is a member of the American Watercolor Society, the Southern Watercolor Society and the Baltimore Watercolor Society. He has always been driven to paint, but his real love is fly fishing and golf. Any one of these activities provide enough reward and frustration for a lifetime.

Painting Light and Shadow in Watercolor. Copyright © 1994 by William B. (Skip) Lawrence. Printed and bound in China. All rights reserved. No part of this book may be reproduced in any form or by any electronic or mechanical means including information storage and retrieval systems without permission in writing from the publisher, except by a reviewer, who may quote brief passages in a review. Published by North Light Books, an imprint of F&W Publications, Inc., 1507 Dana Avenue, Cincinnati, Ohio 45207. (800) 289-0963. First edition.

Other fine North Light Books are available at your local bookstore, art supply store or direct from the publisher.

00 99 98 97 5 4 3

Library of Congress Cataloging in Publication Data

Lawrence, William B.
 Painting light and shadow in watercolor / by William B. (Skip) Lawrence.
 p. cm.
 Includes index.
 ISBN 0-89134-577-9
 1. Watercolor painting—Technique. 2. Shades and shadows. I. Title.
ND2365.L38 1994
751.42'2—dc20 94-21078
 CIP

Thanks to each artist for permission to use art.

Edited by Rachel Wolf
Interior design by Sherri Stoffer
Cover design by Brian Roeth
Cover illustration by William B. (Skip) Lawrence

METRIC CONVERSION CHART		
TO CONVERT	**TO**	**MULTIPLY BY**
Inches	Centimeters	2.54
Centimeters	Inches	0.4
Feet	Centimeters	30.5
Centimeters	Feet	0.03
Yards	Meters	0.9
Meters	Yards	1.1
Sq. Inches	Sq. Centimeters	6.45
Sq. Centimeters	Sq. Inches	0.16
Sq. Feet	Sq. Meters	0.09
Sq. Meters	Sq. Feet	10.8
Sq. Yards	Sq. Meters	0.8
Sq. Meters	Sq. Yards	1.2
Pounds	Kilograms	0.45
Kilograms	Pounds	2.2
Ounces	Grams	28.4

DEDICATION

To my wife, Shauna, and our children, Carly and Joshua

ACKNOWLEDGMENTS

My thanks to: My mother, Jeanne Marie, and father, Wolford Wesley, for supporting me in everything I wanted to do. Mom always wanted to go to art school, but never had the opportunity. She made certain that I got the chance and then became my student. For the last 20 years of Dad's life, he was not only my friend, but framer.

Morris Green, my high school art teacher, who taught me much as student and peer.

Don Stone for reminding me that art is the ultimate goal of artists and watercolor is just a medium.

Edgar A. Whitney, my first watercolor teacher, for giving me a solid foundation upon which to grow as an artist.

Christopher Schink for moral support and helping me to confirm or clarify many ideas.

Thousands of students who encouraged me to write this book even though I sometimes confused them as my instruction evolved. Especially Jack Futterman, who has directed me in the fine art of logical thought and communication.

Rachel Wolf, my editor, for her help and encouragement as I ventured into unfamiliar territory.

CONTENTS

Introduction

Chapter Six: Making Color Decisions

Chapter Seven: Developing Contrast

Chapter Eight: Creating Moods

Chapter Nine: Achieving Unity in Your Paintings

Chapter Ten: Designing With Light: Four Demonstrations

Conclusion

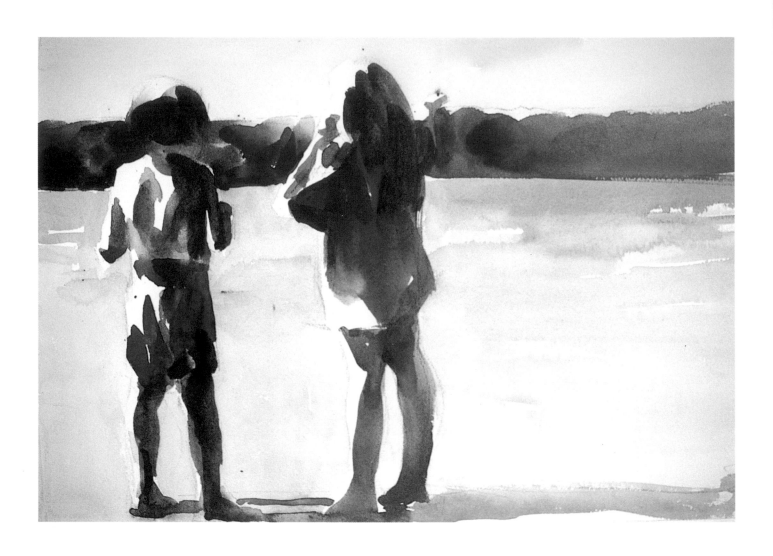

INTRODUCTION

While I was painting in Maine one summer, two Mainers happened to meet within earshot of where I was working. One said to the other, "Where you goin'?" Response, "I dun'no." To which the first replied, "How you gonna know if you got they'ya?"

It is important to know where we're going as painters. Important for several reasons. One is we want to be able to evaluate progress. Without a goal it is impossible to make an evaluation of success or failure. It is important to be specific concerning a goal. Vague generalizations are as worthless as no goals. The person who says his or her goal is to do a good painting is really only *hoping* to do a good painting. The number of elements that make up a painting are too numerous for us to consider simultaneously while in the process of painting. Rather, we must decide on one or two elements that will be of concern in a piece of work, and allow all other elements to take care of themselves. How successfully these peripheral elements are handled depends largely on experience — experience gained when these other elements were of ultimate concern and given our undivided attention.

The elements we choose to feature in a painting basically come from one of two sources: formal design elements or expressive goals. Formal elements are line, value, color, texture, shape, size and direction. These are the elements that, no matter what the source, ultimately must be used for painting. It would take a lifetime to explore the possibilities provided by these formal elements alone.

Expressive goals are more personal and perceptual. Two people look at Manhattan. One feels anxiety, the other exhilaration. Since there are no tubes of anxiety or exhilaration available for purchase, painters must translate these perceptions into elements of color, line, direction, etc. Whether your goals are founded in formal elements or are expressive goals, it is wise to decide "where you're goin'."

I paint because it interests me. I can't find anything that interests me more. Painting isn't fun, though sometimes the results are funny. Painting is frustrating, rewarding, calculating, spontaneous, revealing, obscure, hard work and sometimes relaxing. Dedicating yourself to this quest makes a lot more sense if you have a clear objective. We don't all paint for the same reason. If it's your goal to make money, you should look to those who have been a commercial success. *Parade* magazine published the salaries of some notables and gave P. Buckley Moss's income as $500,000 yearly. If your goal is membership in national organizations of watercolorists, you should perfect your watercolor techniques. To win awards, you should paint large. But please don't take these suggestions as gospel. My advice is not offered to tell you how to accomplish a goal, but rather to encourage you to clearly identify your goal.

Avoid thinking of yourself as a *watercolorist*. Your objective is not to become the best technician of the medium of watercolor, but to be the best *painter* you can be. Watercolorists are too often thought of as technicians whose concern for ideas, communication, perception and aesthetics are of secondary importance. This is due to many factors, some legitimate and some erroneous. It is true that there exists an inordinate emphasis on techniques in watercolor. Only watercolorists and pastelists choose to identify themselves by their media. There are no oilists or acrylicists. Think of yourself as a painter who uses watercolor pigments on paper. Having taken this philosophy to heart you will free yourself from the limitations of imposed "thou shall" and "thou shall not" rules, rules that say, "watercolorists can't use white pigment." Who decided that we can't use white paint? It certainly wasn't John Singer Sargent or Winslow Homer for they both used white paint. Fortunately, professional contemporary painters in watercolor do not abide by these restrictions.

Another problem is the result of being organized into national, regional, state and local societies, which use watercolor as a rallying point. Once organized and named, these organizations are targets for anyone who feels artists should be fiercely isolated individualists. While much of their criticism is unfair and unfounded, there are drawbacks to being organized. The most harmful aspect of organization is conformity. There will always be those who are considered by majority consent to be "the best." Once the best has been established, then a model is made clear. As people aim for the established model, individual potentials are lost. It's very hard to be part of a group and maintain your uniqueness.

The solution is simply to have and maintain your own sincerity. Learn all you can about the formal elements, the history, your contemporaries, and what artists think about. Ignore simplistic teaching, formula solutions and "follow me" approaches. Know that the best part of painting is enjoying the search, not reaching a nonexistent end.

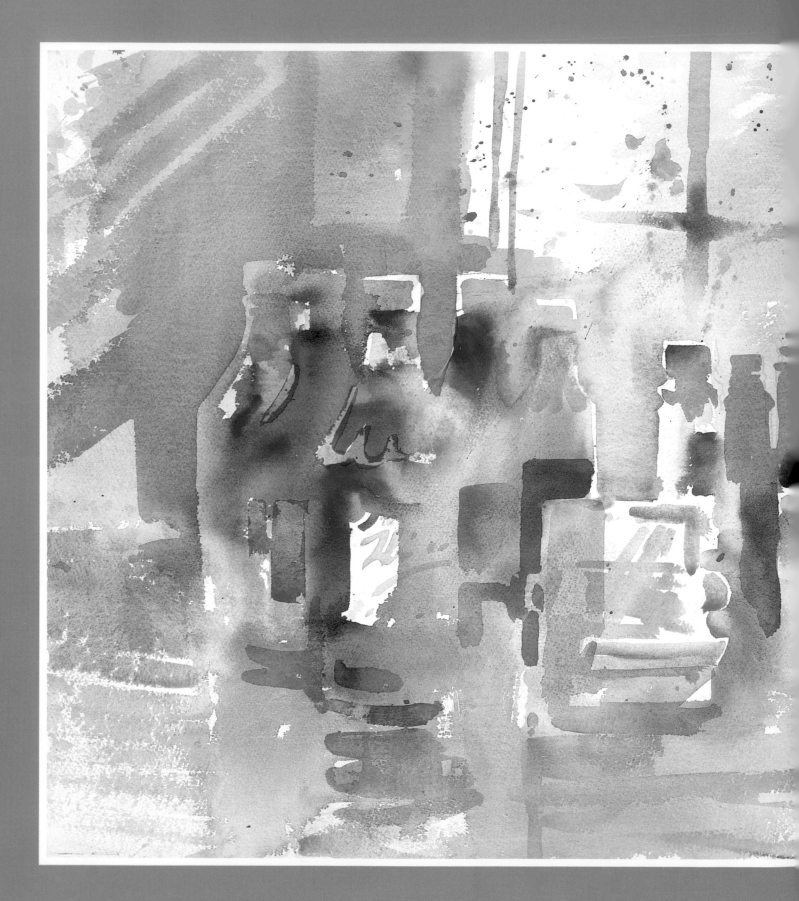

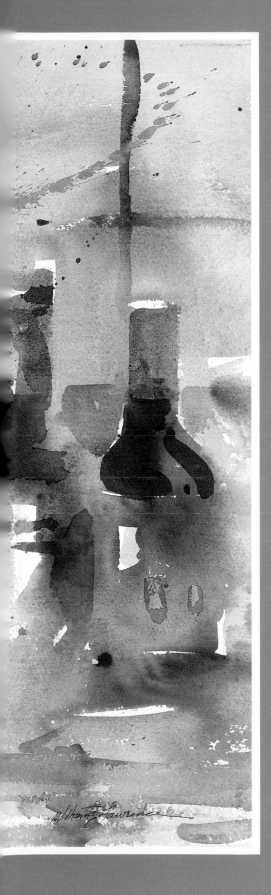

Chapter One

SEEING SHAPES, NOT THINGS

How to Simplify What You See

I was twelve years old when my first painting teacher told me to "simplify" my painting. This was the first of an endless number of teachers all saying the same thing, "you should simplify." As it turned out, it was great advice. The problem was that no one explained *how* to simplify.

I will now give you an approach that will allow you to simplify your paintings. Wait for a sunny day. Then grab your easel and head for a suitable painting spot—not too complicated, nor so simple that it doesn't allow for a challenge. It will also help, for at least the first attempt, if the subject matter is light in value. White objects are particularly good because they make it easy to see the patterns of light and shade. Because dark surfaces absorb light, they are not as helpful for this exercise.

Position yourself where your view of the subject provides a clear pattern of sunlit surfaces and shaded areas. Now you can begin the process of simplifying your paintings by seeing *shapes*, not *things*. Instead of taking the approach of seeing a collection of individual objects—a house, a car, another house, two trees, a picket fence, and a partridge in a pear tree—squint your

Like any complicated endeavor, it is an understanding of the biggest concepts that is our avenue to success.

eyes and see only two shapes. Shape One will be everything that is in *sunlight*. Shape Two is made up of everything that is in *shadow*. You have now simplified numerous objects into two identifiable shapes.

As you begin to draw you must proceed with caution, for if you revert to old habits and draw each object, rather than two shapes, you will have negated the very essence of your new approach. Your pencil lines should follow the edge of light and shade. The

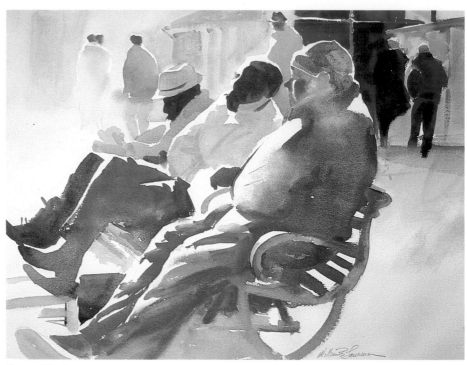

Inner Harbor
20" × 26"
Collection of the artist

Painted one warm winter day at the harbor in Baltimore, this painting celebrates light and shade as the figures enjoy the warm winter light.

resulting drawing will be a rather strange-looking pattern of abstract shapes that should be generous in size. Try to touch each edge of the paper.

Freed from the constraints of painting twenty-five separate objects—each with 360 degrees of edge—you can now execute a more spontaneous expression of your feelings.

Begin with the idea that what is in light will be left as white paper. You are now faced with but one shape to paint—the shape of shade. Paint the shape as an abstract pattern. Don't allow yourself to be overly influenced by local color. Begin at one end of the shape and paint to the other. One approach is to first wet the entire area of this shape and drop in colors. Take this opportunity to experiment.

What I have briefly outlined is the foundation upon which this entire book is built. For like any complicated endeavor, it is an understanding of the biggest concepts that is our avenue to success. To achieve success in painting,

Stop thinking about brushes, pigments, paper, how to hold your brush, how to draw a house, and think about shape and color.

most students need to change their concepts while forsaking old habits. After twenty years of playing golf, all without professional instruction, I met a PGA touring professional. A deal was struck that I would teach him to paint in exchange for golf lessons. After watching me hit several balls, he informed me that while my swing had some good components, my concept was wrong and there was no hope of improvement until I changed my fundamental approach. I have spent the last five years unlearning bad habits. If you would like to become a par or better painter, stop thinking about brushes, pigments, paper, how to hold your brush, how to draw a house, and start thinking about shape and color.

Designing With Light

The idea of "designing with light" is not offered as "the best" or "only" approach I use. It is an approach which works. Sunlight is powerful stuff. It can make a black roof appear white and white objects look black. By seeking patterns of light and shade we are freed from the object-by-object routine. Because of the single light source, the sun, there is most often a rhythmical connected pattern of both the light and shade. By moving slowly around a potential subject and observing the shapes created by the light and shade, you can find the pattern that is most interesting.

Your relative position to the object and the light source changes not only the patterns but also the effect. Sunlight hitting you on the back of your head creates small pieces of shadow on the subject, leaving much of the paper white. Sun in your face offers a backlit subject making large dark shapes with rim lighting. Side lighting makes for balanced amounts of light and shade with horizontal cast shadows. This is most traditional and requires considering how balanced you want the amounts of light and shade to be. Generally it is not good to have equal amounts.

The same ideas apply when working in the studio, from still life or figures, using artificial light. Multiple light sources make it difficult to see patterns and should be used only by professionals. Do not try this at home without supervision!

Backlighting a subject makes a large connected shape of shade with rim lighting. This is one of my favorite lighting choices because it unifies so many shapes into generous patterns.

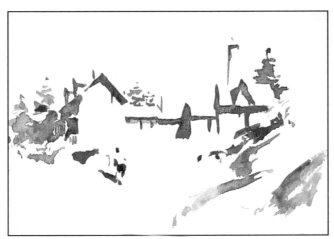

Front lighting produces disconnected spots of dark (shade). When read as a whole and placed against a larger shape, these spots of dark express light and describe objects beautifully.

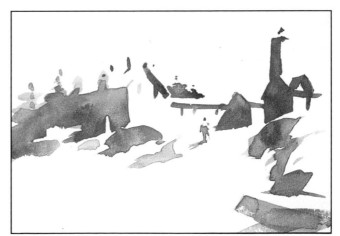

Side lighting makes alternating shapes of light and dark. This lighting can be a bore without careful consideration of the amounts and size of light and shade. Position yourself where the light outweighs the shade or vice versa.

Number and Placement of Shapes

The number of objects in a scene has an effect on the outcome. One isolated barn, silhouetted against a flat sky, doesn't provide the chance to connect shapes of shade that makes for more interesting patterns. On the other hand, an attempt to see and connect the pattern of five hundred people crossing a busy city street is more aggravating than instructional. Select a moderate number of objects that vary in size and create interesting connections. I apologize for being rather vague on the "just right" number. I am reminded of my son's baseball coach whose instruction on batting was to "hit the ball." The illustrations will help to provide a clearer picture.

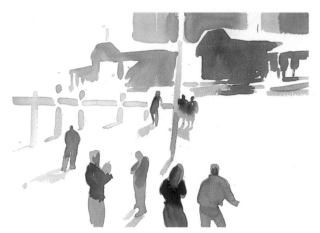

Too many isolated shapes drive viewers crazy as they frantically try to organize disjointed shapes.

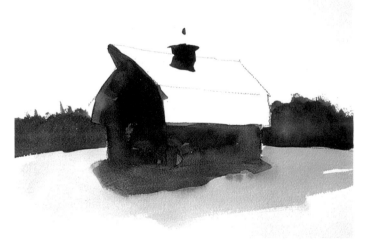

Too few shapes lack visual interest.

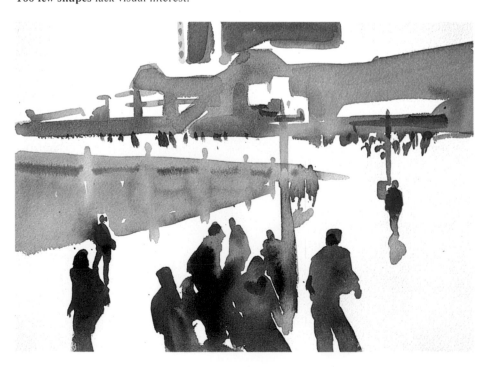

A balance of number and placement makes for visually exciting compositions.

Building Patterns by Overlapping

A single row of shapes running horizontally across the paper makes a simple silhouette. Like the response I once got from a friend when I asked, "How do you like this painting?" After some thought he responded, "I like the simplicity, the utter simplicity." The painting was so simple as to be a total visual bore. To avoid this problem, and a similar critique, look for subjects where the shapes are more interesting, because of the effects of overlapping objects. By including shapes from the foreground, middle ground, and background when designing the large patterns of your art, you will find two major improvements. One, the edges will be more varied, and two, the dynamics of depth will appear.

Depth Is Lacking

One silhouetted shape looks like a stage set lacking depth, intrigue and interlocking edges.

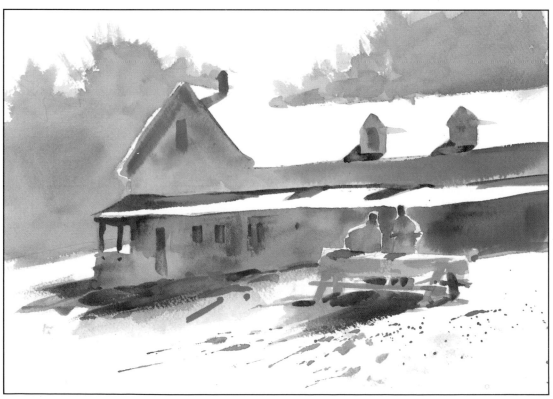

Depth Is Created by Overlapping Shapes

The viewer is invited to move in and out of the painting as well as across the picture plane.
The shape is more dynamic because the eye moves from one object to another in a rhythmical progression from foreground to background.

Building Patterns by Connection

I cannot possibly overstate the importance of this topic. Some call it connections. Others say linkage, lost and found edges, or bridges. They're all terms used to describe joining a portion of one edge of a shape to another shape. It is precisely these connections of edges that make passages and patterns so our eyes move gracefully through a well-composed piece of art. The alternative is a stop-and-go, herky-jerky trip through the barricades of hard edges erected by "terminal literalists" (a term of endearment given to those who are killing themselves through their strict adherence to absolute visual facts). I believe this widely used approach to painting to be the result of the coloring book. There we were encouraged and even chastised by some to "stay inside the lines." Joy, creativity, enthusiasm and kinetic sensation have been stifled in the name of neatness. I see students every day whose talents and goals are arrested because of a pencil line. It is as if there is a negative charge in a pencil line that repels a wet brush from crossing it. Go ahead. Cross the line. All great artists have; why shouldn't you?

Connect Edges

In this painting of figures, cows (I guess) and barns, the objects, whether foreground, middle ground or background, are unified as a single shape. I was careful to connect as many edges as possible. Notice how many edges are completely melted together without any loss of content.

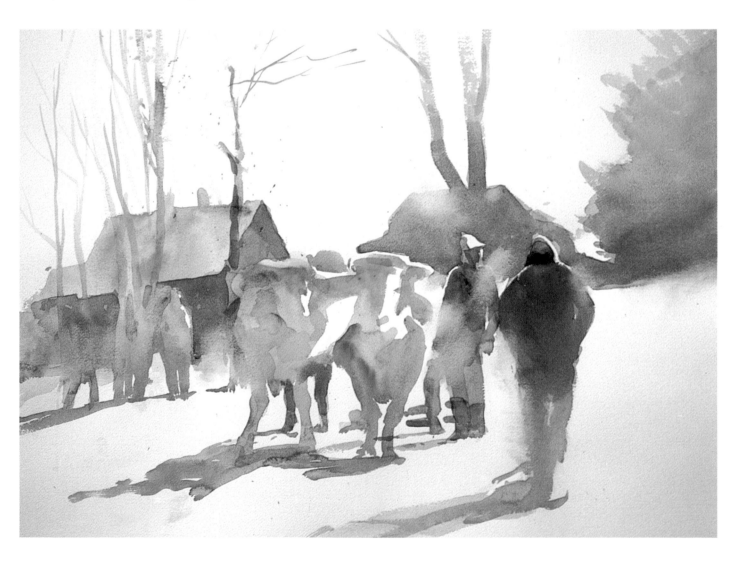

DEMONSTRATION: *Using Light to Express Emotion — Two Approaches*

Study the two approaches of style and concept to *Keeper's Place*. The first painting represents a traditional handling of the subject. It is an accurate depiction of shapes, values and color. In my classes I refer to this approach as the most impersonal choice—the "path of least resistance." The artist is not sharing ideas and feelings. Of the five senses, only sight is called on to make decisions. All that is required of the artist is the ability to draw accurately and match colors. These types of paintings are perceived not as coming from the hand of a thoughtful, emotionally involved artist, but rather from someone detailing a list of things seen on vacation.

In my classes I often ask people to give me the one word that best expresses their feelings about New York City (I use NYC only because everyone has an opinion on the subject). Typical responses run the gamut from dirty and scary to exciting and beautiful. These opinions are the result of much more than visual observations. Included are the sounds of taxi horns and the opera, the smells of Central Park and bus exhaust, the feel of crowds pushing past you and the warm sun on a cold day. It is the aggregate of these experiences that forms opinions and perceptions. Awareness and use of these feelings and understandings make paintings uniquely yours.

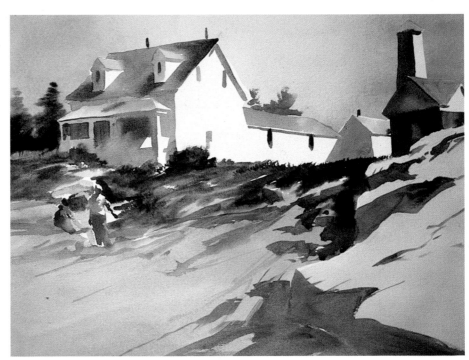

Keeper's Place I
20" × 26"

This version is done in a traditional realistic way. It is accurate in shape, value and color, but it lacks poetry, personal style and evidence of interpretation.

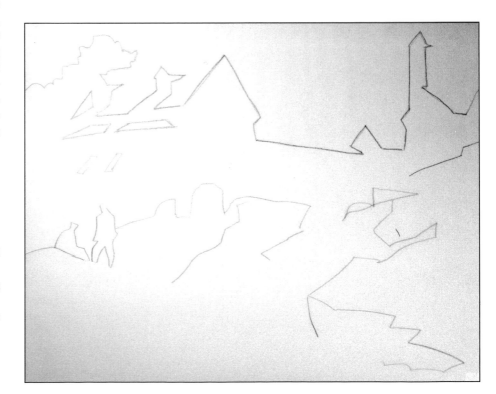

Keeper's Place II, Step 1
It is essential to establish your approach and identify your goal from the beginning. With this in mind, I begin the drawing by outlining the shape of shade, ignoring the shape of objects. I am careful to complete each shape by including all 360 degrees of edge. Notice that the line that describes the shape of shade includes many separate objects as it moves from house to rock to figure.

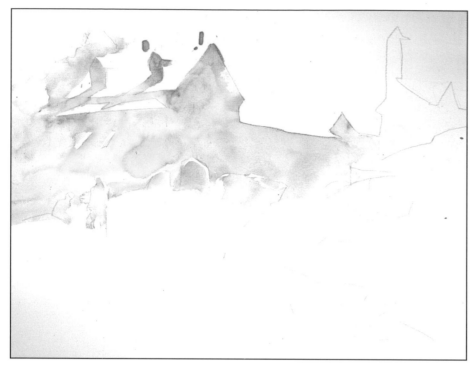

Step 2

My initial thoughts, when applying pigment, are of color. Color temperature, color intensity and color changes are all important here. The value contrasts are kept to a minimum to avoid fracturing the unity of the big shape. By working from one end of the shape to the other, I avoid unwanted edges where wet paint is applied over dry. Another approach is to wet the entire shape with either a light value wash of color or just water and proceed by charging in sequential colors.

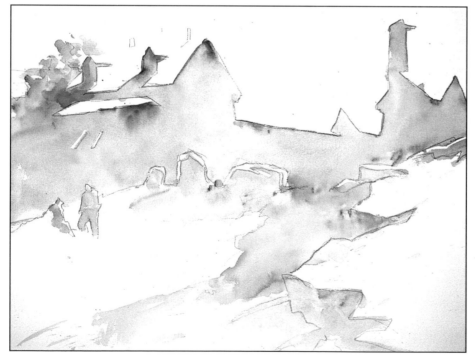

Step 3

After completing and evaluating the entire shadow shape and while it remains damp, I put in color intensity and color temperature changes. The most intense color contrasts are placed where I want to draw attention. It is here that I also introduce minor value changes. Remember the word *minor*! More paintings are ruined by adding darks than any other element. Please, no black windows, yucca bushes, or other out-of-this-world dark things.

The second version of *Keeper's Place* is about light. I moved the sun behind the subject to create a more unified pattern of the entire scene. In so doing I linked figures, trees, building and rocks into a continuous flowing pattern of shade. The expression of light is more obvious when unified in its placement and generous in size, rather than broken into small spots

> *Color is the most expressive element in the artist's vocabulary. To relegate color to a secondary role is to communicate with half a vocabulary.*

where light haphazardly hits the sides of isolated objects. The opposite of light is shade. I unify the pattern of shade for the same reason as light. I want you to see shade, not buildings, trees and figures. By unifying the pattern of shade I am free to paint the shape of shade in a variety of colors and intensities that express my feelings of warmth and excitement for the subject and day. Values should be kept close in contrast to maintain the unity and flow of the shape.

Color is the most expressive element in the artist's vocabulary. To relegate color to a secondary role is to communicate with half a vocabulary. Notice the color differences in the two versions of *Keeper's Place*. Color selection in the traditional painting is based on color identification. What color do I see? In the other, there are color *choices*. My decisions were made to express what I felt and understood about the subject. In twenty-five years of teaching I have not had the first student ask, "Can you teach me to be tight?" Everyone wants to paint exciting, spontaneous watercolors. Nothing could be less spontaneous or exciting than a slavish rendering of local color. Don't paint what you see, paint the excitement you feel for the subject. And if the excitement is not there, find another subject.

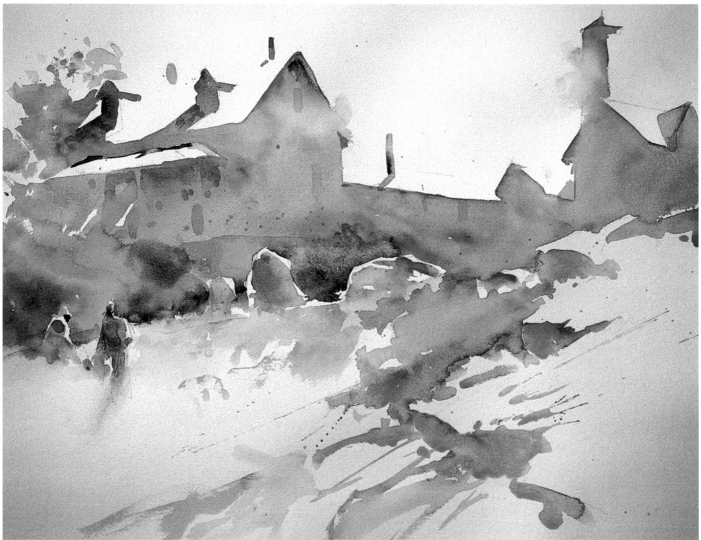

Keeper's Place II
20" × 26"

The finishing touches remain subtle (perhaps finishing touches should be called tender touches). Any additions that challenge the overall pattern should be left out. I look at edges rather than interiors to add interest and change. A little cooler behind the rocks, brighter at the edge of the roof, an indication of grass here and there is all that is necessary to complete this job.

Remember:

- To simplify your paintings, paint the shapes of light and shade.

- It is important to position yourself to the subject at the spot where the light and shade make the most interesting shapes.

- The number and placement of shapes is compositionally important.

- Overlapping is the simplest and most effective way of creating space.

- Joining small shapes makes large patterns.

- Take time to verbalize vague notions into concrete ideas.

- Select the most appropriate elements to express ideas and emotions.

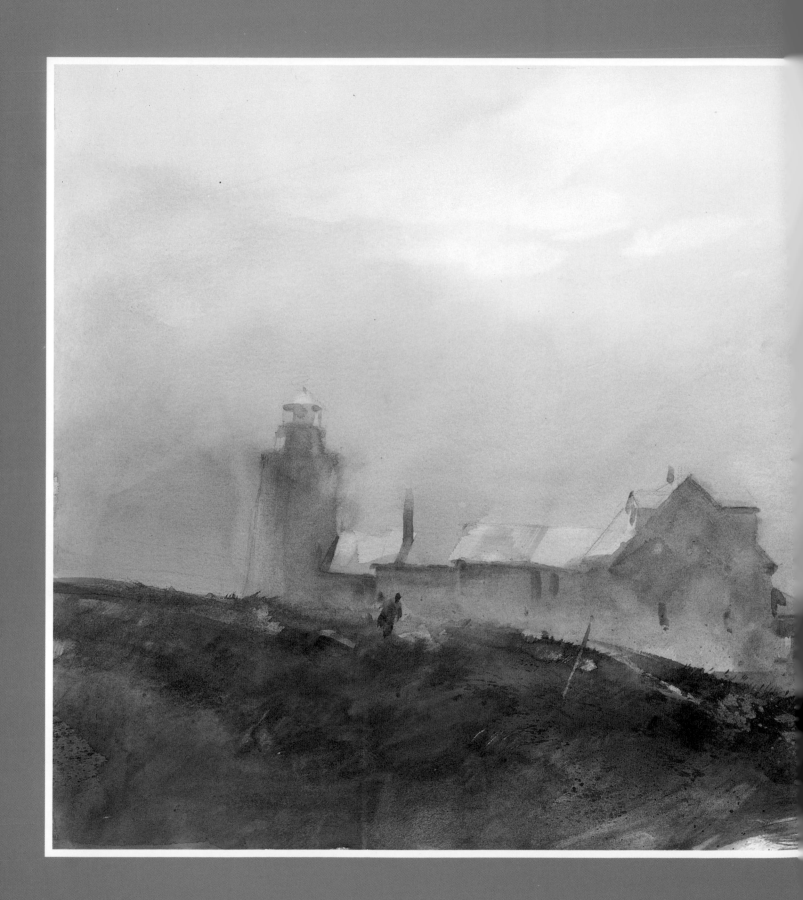

Chapter Two

DESIGNING WITH LIGHT AND DARK

Seeing the Pattern of Shade

Seeing the shape of shade is not as easy as it sounds. Several hurdles must be cleared before patterns of shade can be accurately observed and subsequently useful when designing. The first is to disengage the brain. Yes, you heard me correctly. This is not something I suggest you do to excess, but it is helpful when the objective is to observe clearly. The brain has too many opinions as to what you should see and often overrides what your eyes actually see. I remember a conversation with a student who was carefully painting blue sky around the shape of a backlit white house. Because of the backlighting, the white house was not lighter than the sky but darker than the sky. When I asked if he could see

> *The most dramatic and instructive approach to the idea of "designing with light" is to begin by exaggerating the contrast of light and shade.*

this, he responded, "It's white." I agreed that it had been painted with white pigment, but that the lighting conditions made it appear as dark against light. He once more looked carefully at the house and told me, "But it's white!" I didn't dare mention that the sunlit lawn was also lighter in value than the white house! This was a case of the brain blocking the eye.

The second hurdle is to disregard local color and surfaces that absorb light, making it difficult to observe light. The perception of color is directly related to the reflection of light waves. Dark surfaces absorb much more light than do light surfaces, which makes it hard to see them as light-struck. Porous surfaces, such as roof shingles, grass, foliage and sweaters, also absorb

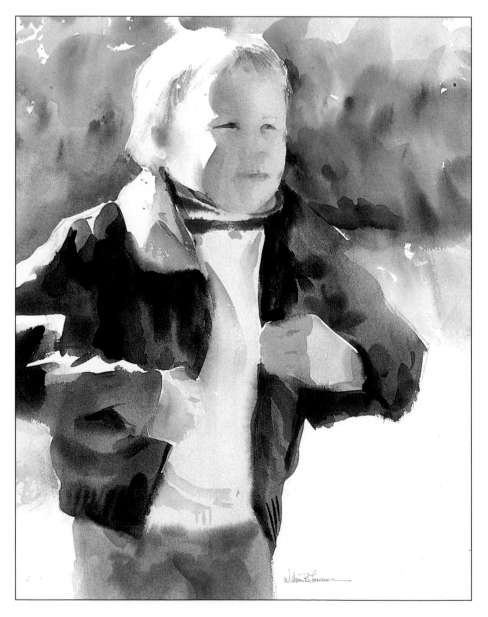

Joshua
20″ × 26″

This painting of my son, Joshua, demonstrates how to design with the shape of shade. Notice that the shapes used do not represent the shape of head, coat, shirt and pants, but only that portion of these objects that is in shadow. The portions in sunlight remain white.

light and can look dark in direct sunlight. On the other hand, shiny surfaces can fool you because they reflect values from other surfaces. Water often appears dark when reflecting shaded surfaces even though it is in direct light.

Here are some ways to keep from being fooled by absorbent and reflective surfaces. Identify the source of light, be it the sun or a lamp, and remember that anything perpendicular to it is in light. Look for cast shadows. Any surface that has cast shadows on it is in light. As I stated earlier, dark surfaces are difficult to read. Look for their angle to the source of light and for cast shadows. A shadow identifies

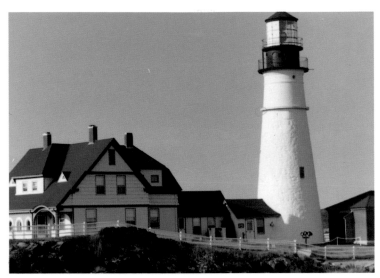

Photograph of Portland Head Lighthouse

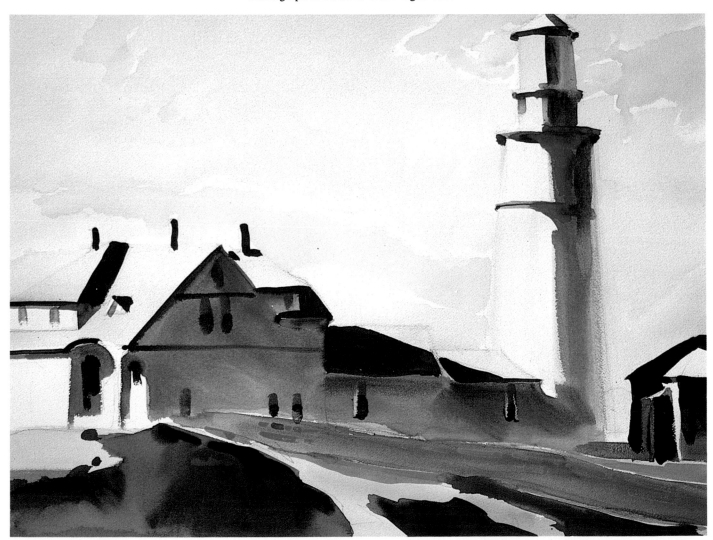

Portland Head Light
20″ × 26″

To create the large shape of this painting, I massed together the entire shape of shadow. Comparing the two shapes you will see that the shape of shade is more interesting than the shape of the lighthouse. Notice that part of the orange roof is missing. The missing section is unnecessary and its omission creates a more beautiful shape.

the direction of the light and whether the surface is in light. There will be times when the white of a house in shadow is a darker value than the black of its roof in sunlight.

The beauty of seeing the patterns of light and shade is the compositional possibilities provided. There will be times when you elect to ignore the effect of light on a color—times when it is compositionally advantageous to paint the sunlit roof black and times

Armed with the idea of designing with light—and shade—there are infinite possibilities as to the relationship of one to the other.

when it is best to paint the black roof light. The point is, you do have the choice. Charles Reid wrote a book titled *Painting What You Want to See*. My friend Don Stone said his title would be *Painting What I Thought I Saw*. I would include in this library *I Couldn't See What I Was Painting*.

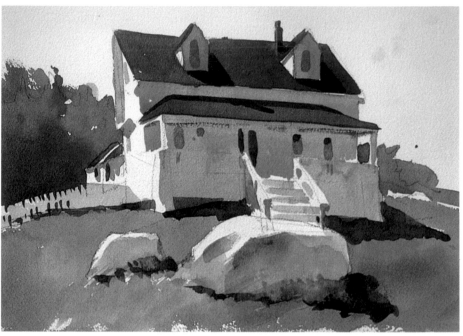

Version one.

I mentioned the occasion when the white of a house in shadow might appear darker than a black roof in sunlight. In version one, I elected to use local color—black roof, white house. This is not accurate to the eye, but certainly makes sense to the brain.

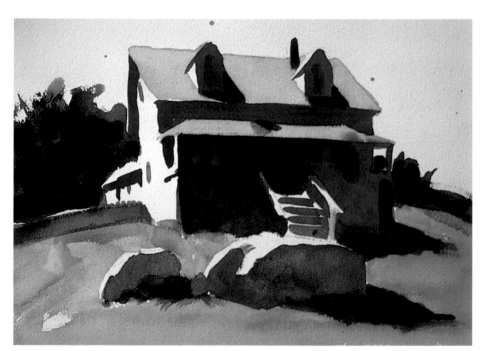

Version two.

In the second version there is visual accuracy. The black roof does appear lighter in value than the shadow portion of the white house. Don't take my word on this. Take the time to make these observations, and they will be more believable to you and provide options when you design.

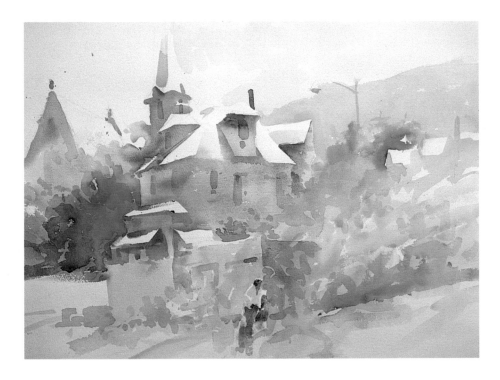

Cumberland, MD
20″ × 26″

Only the planes that are in shadow are painted. By keeping the values relatively close, I am able to change color freely with emphasis on expressiveness.

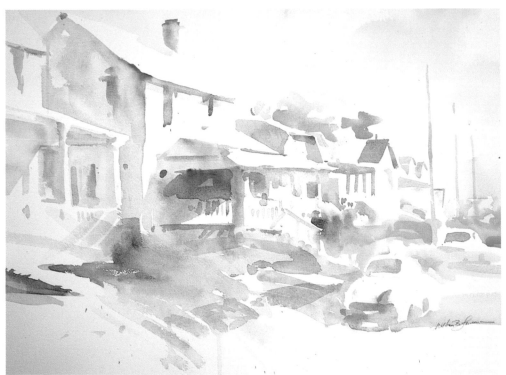

Beaufort, NC
20″ × 26″

An early morning walk on the side streets of Beaufort, North Carolina, provided this pattern of sunlight and shade. The low morning direction of light created a beautiful network of shapes. The color choices were arbitrarily applied to create the freshness of the day.

Seeing Sunlight as White

Begin by leaving every shape that is in light as white untouched paper. This means that you totally disregard local color and value. A black surface receiving sunlight is left white. A red, yellow, blue or green surface in light is left white. Be committed to this idea. While this approach sounds easy, it has been my experience that students have a terrible time remaining consistent with the concept. Skies and lawns seem to be particularly difficult. A clear blue sky, without clouds, should be interpreted as white paper. The flat planes of a lawn remain white. At this point I can hear you saying, "Heck, he wants me to leave the entire paper white!" And yes, there will be times when 90 percent of the watercolor page is untouched. It depends on the light source. On other occasions, 90 percent of the paper will be painted. The trick is to remain consistent in identifying and painting only the shape of shade, and in not painting the shape of light.

Changing the Value Contrasts

Much of the instruction covered in the remainder of this book is based on the idea of the shape of shade and light. Make certain you are clear about this approach before continuing. Let's begin with the contrasts of value. In each exercise the shape of light will be left as white paper with the value of shade being adjusted to create changing light and atmospheric conditions. By painting the shade shape just slightly darker than the light of the page, the subject appears bathed in hazy strong light or thick atmosphere, such as fog. As the contrasts of value get farther apart, moving to black, the light is expressed as stronger and the atmosphere clearer. By experimenting with these contrasts you will see how important it is to nail down the contrasts of value to achieve the desired light effect.

It is eye-opening to experiment with the complete range of value contrasts. An alternative to perceiving sunlight as white is to tint a page with a single value and then paint the shape of shade on top of the tint. See how dark you can make the value of light and still make the shape of shade visible. You will notice that as the value relationship changes, different lighting conditions are expressed, running the range from high noon sunlight to midnight moonlight.

Keep Clear Goals

Great paintings are the result of great shapes and great color arranged in an honest and expressive way. Designing with light lets you create beautiful shapes by simplifying complex subjects into patterns. The last hurdle is to shake off some of the erroneous concepts which stand in the way of this goal. Let me begin by stating that I am not a psychologist and that what I say here has no professional basis. What I do have is twenty-five years of experience observing students who find it very difficult to simplify. I believe much of this is born of the ideas that "more is better," "sweating is evidence of success," and "quality is tied to hours spent." Invariably one of the first questions asked of me about my paintings is, "How long did it take you to do that?"

The old saying "you can't see the forest for the trees" is very appropriate for the painter who paints with tunnel vision and fails to see the overall pattern of shapes and colors. Professional painters strive to simplify, condense, and eliminate details that don't add to the composition, while amateurs seek to describe, embellish and include more details. To improve your painting, throw off old concepts and dedicate yourself to new goals. Ask yourself how many objects can be joined into a generous shape. Seek to design your paintings with three or four shapes rather than ten or twelve. Paint at arm's length and spend as much time walking away and looking at your decisions as applying paint. Keep your goals clear. And keep in mind that "not to decide is to decide."

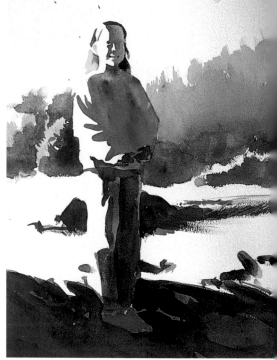

Carly
16" × 12"

In this painting all sunlight is painted as white. No matter the local color of objects, that which is in sunlight remains white untouched paper.

Adjust Values for Different Conditions

In the three examples at right, I have changed the relative values of sunlight and shade. In the first, the light is white paper. In the second, the light is a warm light value and the shade shape is the same value as in the first example. In the third, the value of light is darkened and intensified while the value of the shade is lightened. You can see that by simply adjusting the relationships of value and intensity, different atmospheric conditions are expressed. These are only a few of the infinite number of possibilities.

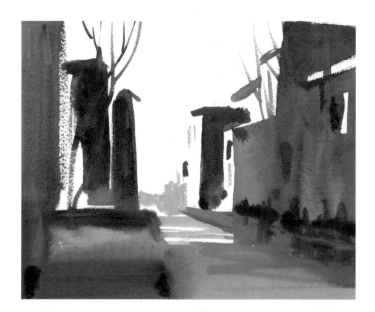

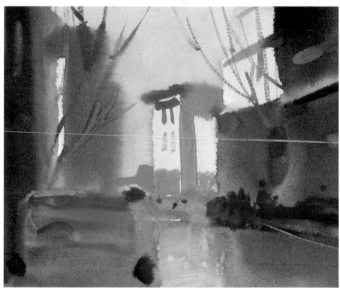

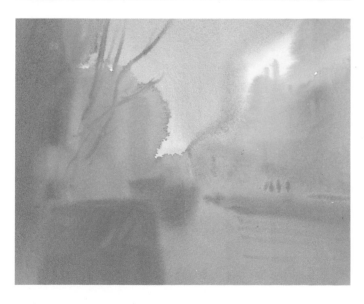

DEMONSTRATION: *Simplifying Complex Subjects With Patterns*

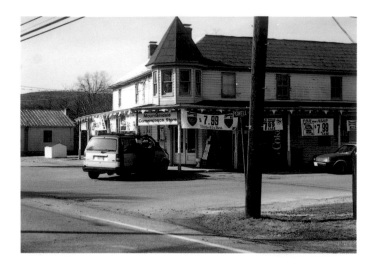

Photo of the Mountaindale Convenience Store in Maryland.

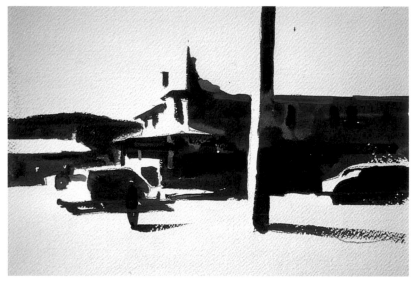

This is a 9″ × 11″ sketch done with dark blues to establish the shape of shade.

Step 1

The drawing follows the outline of the shape of shade and is not concerned with windows, doors, signs, etc. I find it difficult to include these incidentals without having them get in the way when painting. Believe me, the problem with most paintings is not lack of detail.

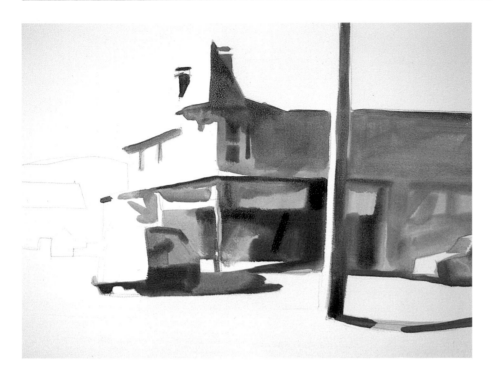

Step 2
The entire shape of the store is blocked in cool colors. A few darker and warmer colors are introduced while the initial wash is still wet.

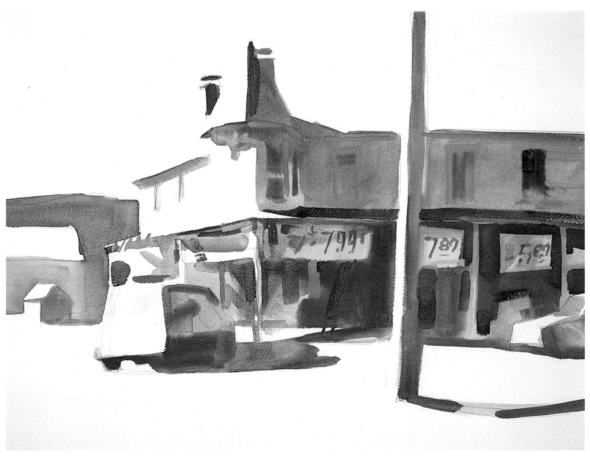

Step 3
The warmer colors of the distant buildings and hills are added to intensify the cool colors of the store. The warm dark shadows of the roof are added for contrasts of temperature and value.

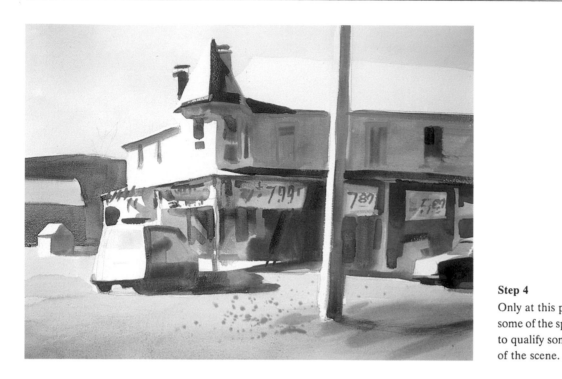

Step 4
Only at this point do I concern myself with some of the specifics of the store. I also begin to qualify some of the light-struck surfaces of the scene.

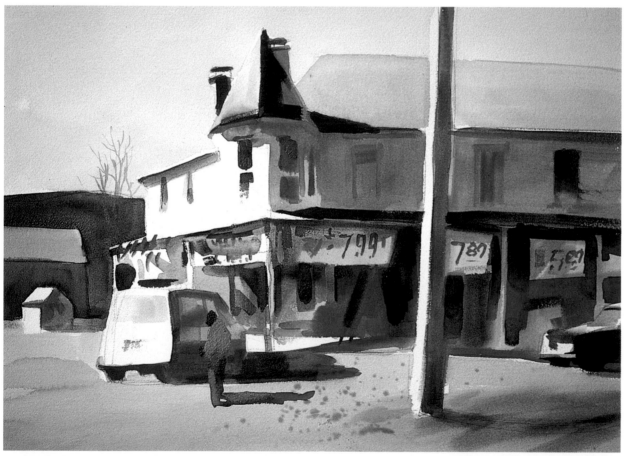

Mountaindale Convenience Store
22″ × 30″

The last step is to judiciously include some of the local color where necessary—the red car, the light red roof.

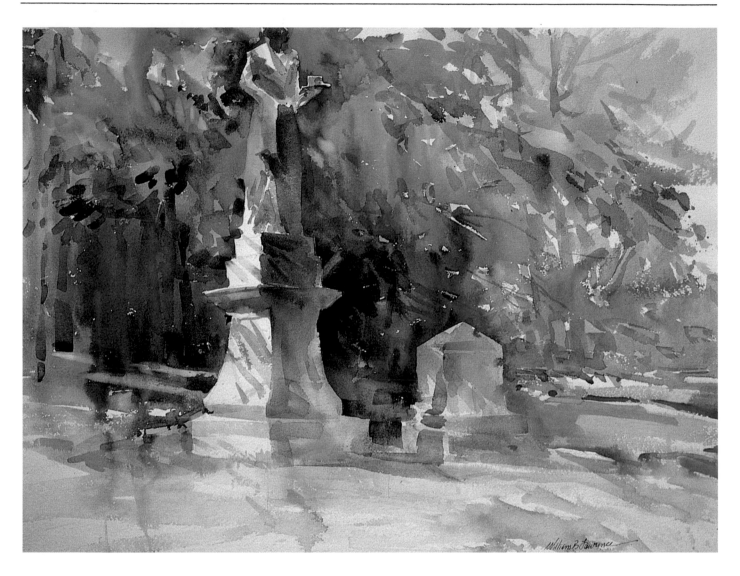

Civil War Mother
20″ × 26″

This statue in Greensboro, North Carolina, is a tarnished bronze color surrounded by pine trees. I created the light and the color to make a painting. There are countless potential subjects just like this statue that require the artist to use imagination. Don't pass them by just because they're not ready-made.

Remember:

- Don't allow your brain to blind your eyes.
- Absorbent and reflective surfaces can fool the eyes from seeing light and shade.
- It is instructive to paint only the shape of shade and leave all sunlit surfaces as white paper.
- The value relationship of light and shade can be altered to create desired effects.
- Good painting is not a product of sweat or time.
- Identify your goals and objectives and keep them in mind when painting.

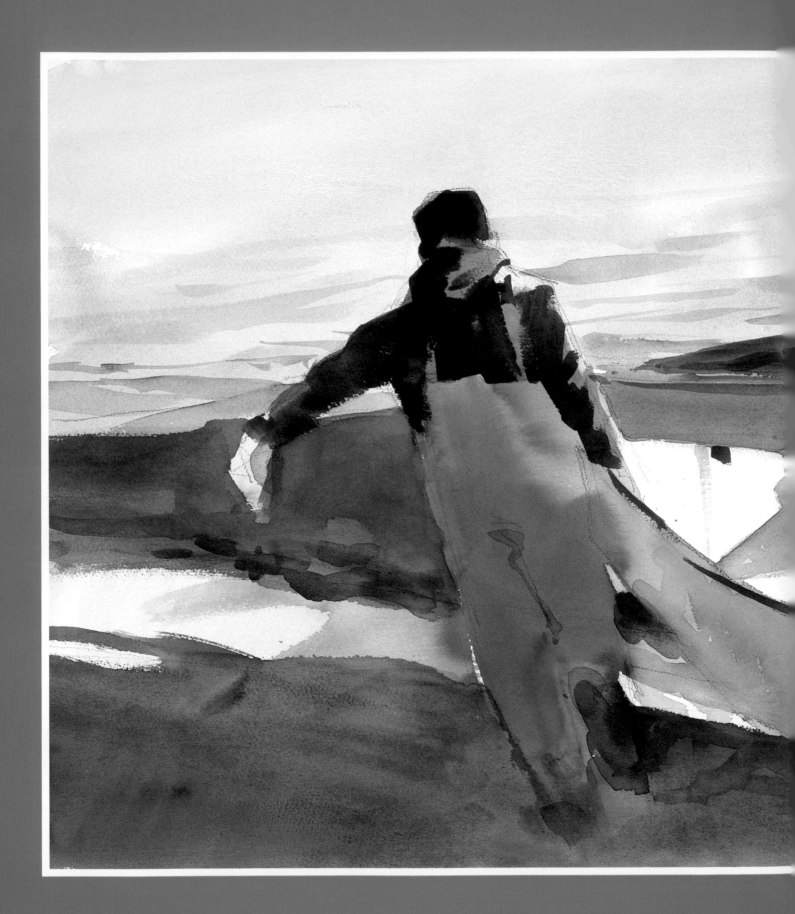

Chapter Three

VALUE ORGANIZATION – A DIFFERENT APPROACH

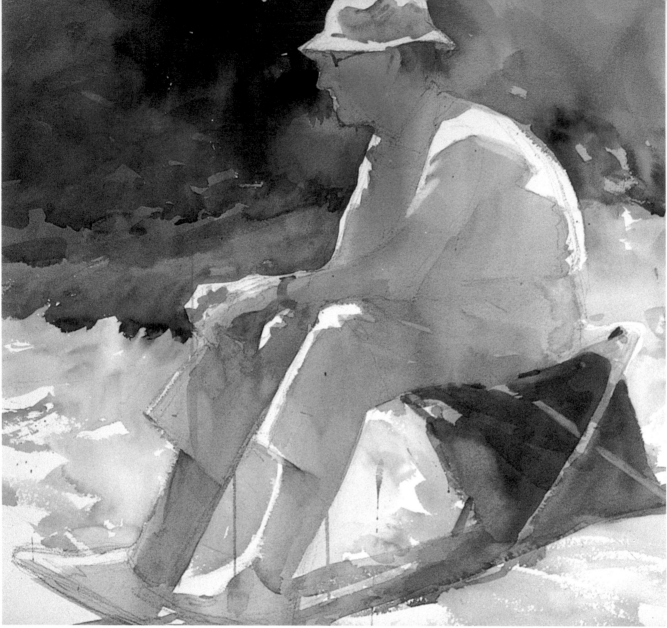

Walter Robinson at Critique
20" × 26"
Collection of the artist

Walter and Vesta Robinson are two of my favorite Mainers. By keeping the shape of Walter simple, I captured the strength of the man.

The 2 Against 1 Approach

There has been much written on using value or tone in the design of paintings. My earliest instructions in watercolor were to first identify the values that were before me and then to categorize the ranges of values into light, middle or dark shapes. These observations were recorded in a sketchbook, with the aid of a soft pencil, and referred to as a value pattern or a thumbnail sketch. The value pattern proved to be an invaluable tool in the process of picture-making. For in the process of making the value pattern, I was forced to organize objects into abstract value shapes. These shapes could be evaluated compositionally for their size and placement. I did discover two drawbacks to the value pattern: One, there was no thought as to color; and two, there was no hierarchy as to which of these three value shapes was the most important. If all three values were given equal care when deciding on their shape, size and placement, then what would differentiate the most important shape from the supporting shapes?

What evolved over years of making value patterns was a slight variation in approach. This variation is more conceptual than scientific. I call it the 2 against 1 approach to value organiza-tion. Here's the difference. Instead of looking at a landscape and identifying the sky as the light shape, the trees as

> **Having a wider range of values allows for greater definition, variety and nuance.**

the dark shape, and the flat planes of fields and lawn as the middle value shape, I would first decide on which of the three available shapes I wanted to feature in this painting (for the sake of discussion I'll select the sky). Having done this, my thoughts are that the sky shape will be created with *light and middle* values (two values) against

darker values (one). Thus the 2 against 1 name. If my choice had been the trees, I would have redirected the emphasis to that shape by designing a *middle and dark* shape against *lighter* values.

If you were to look at two value patterns of the same subject, one done in the traditional way and a second using this variation, you might not notice a great visual difference. The advantage of the 2 against 1 approach is in the concept of the painting. By specifying the major area of importance, a pecking order is determined and a goal is clearly defined. There is also the advantage of allocating a greater range of values for the more important shapes of the painting. Having a wider range of values allows for greater definition, variety and nuance. This approach goes hand in hand with the age-old teaching phrases: "Paint from the specific to the general," and "When painting the focal point, look at the focal point. When painting everything else, continue to look at the focal point." I suggest you take this concept to museums, galleries, and your library of art books and see how often the 2 against 1 organization of values is evident. It won't be 100 percent, but you'll be surprised at the frequency at which this approach is used.

2″ × 3″ Value Pattern
This thumbnail sketch is typical of most shorthand plans. The problem is it fails to identify which of these three shapes is most important. Suggested in this pattern are surf, sky and rocks; each is a potential focal point.

	A	B	C
1			
2			
3			

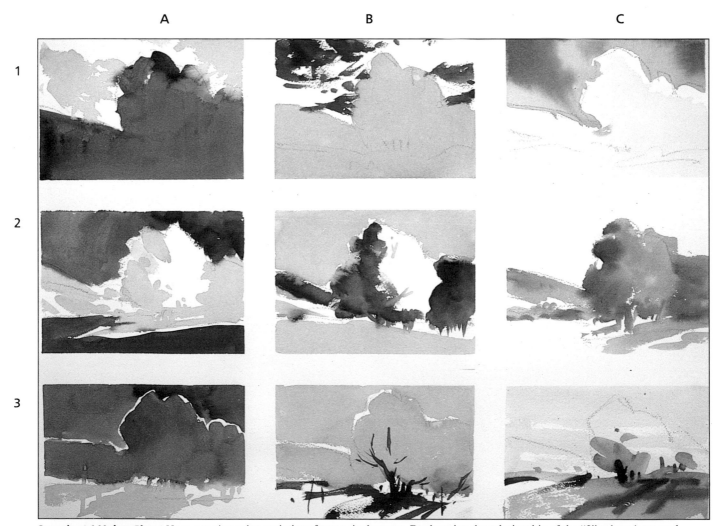

2 against 1 Value Chart Here are nine value variations from a single scene. By changing the relationship of the "2" values (reserved for the focal point) against "1" value (the "everything else" portion of the painting) we can create numerous patterns from one subject. The horizontal rows keep the same focus but change values. Row 1 emphasizes sky; row 2 trees; row 3 foreground. The vertical rows illustrate changing focus. Row A is light and middle values against dark with changed focus from sky to trees to foreground. Row B is light and dark against middle values. Row C is middle and dark against light values.

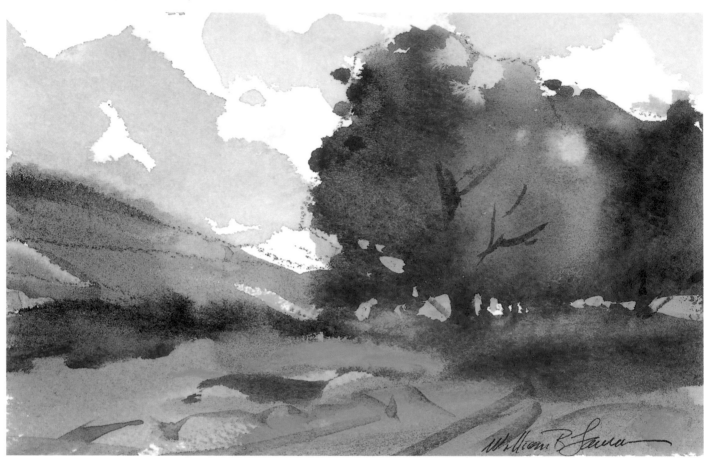

From the Studio
4¼" × 6½"

This little watercolor provided the shapes for the 2 against 1 value chart. It was done in a straightforward approach. This is certainly an option when painting. The problem is that for some it is the only option.

These two variations, of the same size, are color examples from the value chart.

Light and Middle Values Against Dark

This arrangement of values is very common. It is a clean, clear and dramatic presentation of any subject. White subjects are particularly suited to this design. I remember an Andrew Wyeth painting of a white skiff with middle value shadows silhouetted against a black pine forest. Winslow Homer's surf paintings often portray white waves with middle value shadows against dark skies and ocean. Laundry, sails, daisies, and people in white clothing are all popular subjects for this value design. White subjects are not the only subjects for which this arrangement works. Rembrandt's portraits are generally light and middle value heads surrounded by dark. Most traditional landscapes feature a light and middle value sky against a darker

shape of the land. More contemporary examples, in watercolor, include the fish of Joseph Raffael and the nudes of Charles Reid.

Don't confine yourself to using this value design when it appears to be the only and obvious choice. If you ascertain that a dark shape would be better expressed as a light and middle value shape, then by all means do it! The flopping of light, middle and dark values is a fundamental part of your design vocabulary and should be used liberally. Transposing values is a simple procedure. What is offered as a dark shape made of middle and dark values is transposed into a shape in which what had been middle value is now light, and what had been dark is now middle. Just as outrageous colors sometimes prove the best, so also do alternative value organizations.

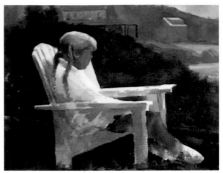

Carly on Monhegan
22″ × 30″

This painting of my daughter on Monhegan Island, Maine is an example of light and middle values against a dark background. By reserving two value ranges for the main shape of the painting, Carly and the chair, I am able to describe the form and feature the shape. Keeping the background shapes close in value (in this case, dark) they do not compete with the purpose of the art.

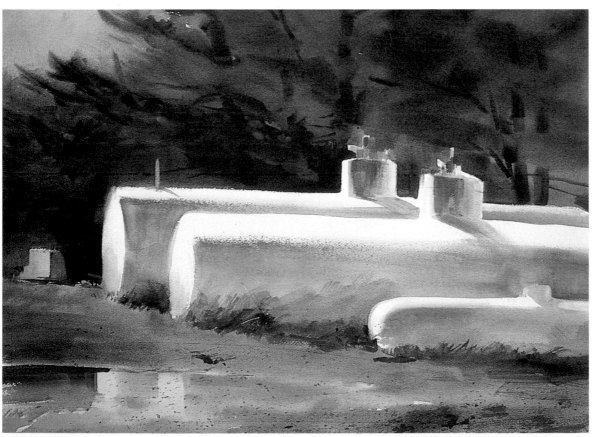

Propane Tanks
22″ × 30″

This demonstration painting shows how the pattern of light and middle values against dark can be used with any subject. I threatened, much of my students' chagrin, to do a series of propane tanks.

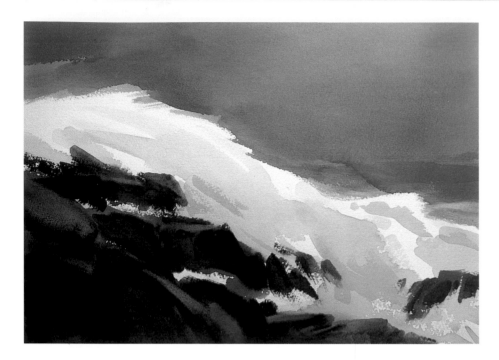

Evening Surf
11″ × 15″

White subjects, such as surf, provide a ready-made subject for this value organization. The plan is to think of the surf as housing both the light values and the middle values against a dark value.

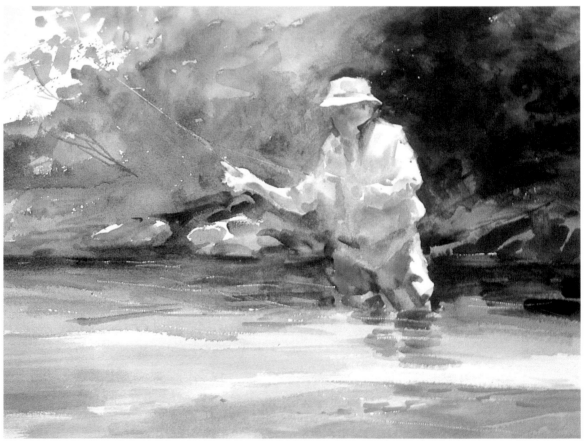

Across and Down
22″ × 30″

This painting of a fly fisherman on a stream in southwestern North Carolina, where I spent some time with our friend Joe Miller, employs the same pattern. In this case, the darkest values are reserved just for the area behind the fisherman's left shoulder.

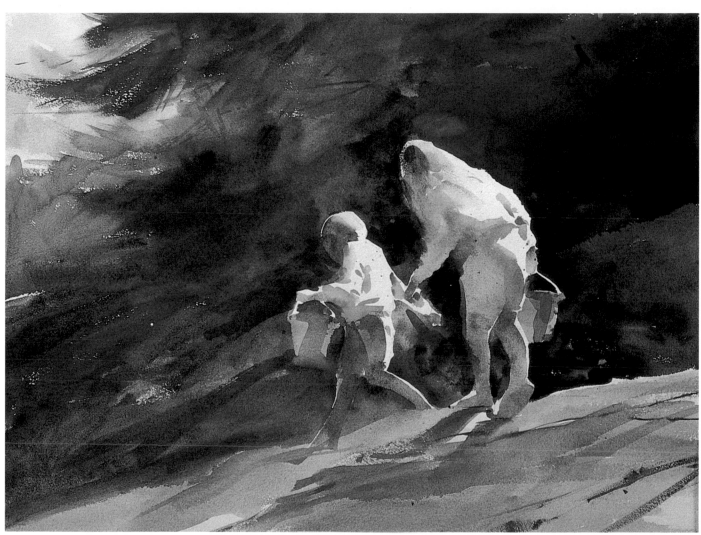

Carly & Joshua on Little Beach
15½" × 22"

Dark and Light Values Against Middle Values

Of the three basic value organizations offered, this option is potentially the most dramatic and also the most difficult. Dramatic because of the strong contrast that happens on the major subject matter. Difficult because the strong contrast can fracture the subject into two unrelated shapes. When the contrast between the light value of the focal point and the middle value of the background are too close, the light value and the middle values join, and the dark shape is isolated. In other words, the light and middle become one shape, and the dark shape stands alone. The same problem occurs when

the dark and middle values get too close. The critical factor is the values that surround the focal point. Too light or too dark, and they won't work.

Objects in direct, strong sunlight are frequently defined as light and dark against middle values. An example is a white house in sunlight. The white in sunlight is lighter than the sky, and the white in shadow is darker than the sky. Once you decide to use this pattern, you must remain consistent. It's easy to get confused by local color and find yourself vacillating between patterns—at one time painting the shadow of the house darker than the sky and at other times lighter than the sky. Once you start down this road, all is lost, the game is over, call in the hounds, and prepare for confusion and frustration.

Bringing together opposites is always chancy. While the contrasts may be dramatic, there is the problem of having the featured shapes bisect, so that either the light or dark shapes join the background and what remains is half the subject. See the illustration on the next page.

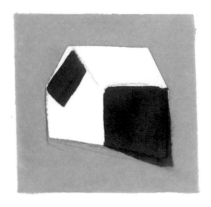

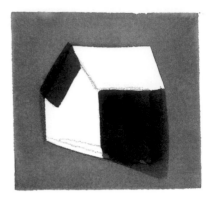

Light and middle join **Light and dark join** **Dark and middle join**

When working with light and dark against middle values, it is critical that the middle values be correct. The middle value on the left is too light, so the light of the building joins the middle value and we are left with two dark shapes that don't describe anything. On the right, the middle value is too dark, leaving us with an interesting, but nondescript shape. But, ah, the middle value in the middle example is just right, allowing us to see a house shape.

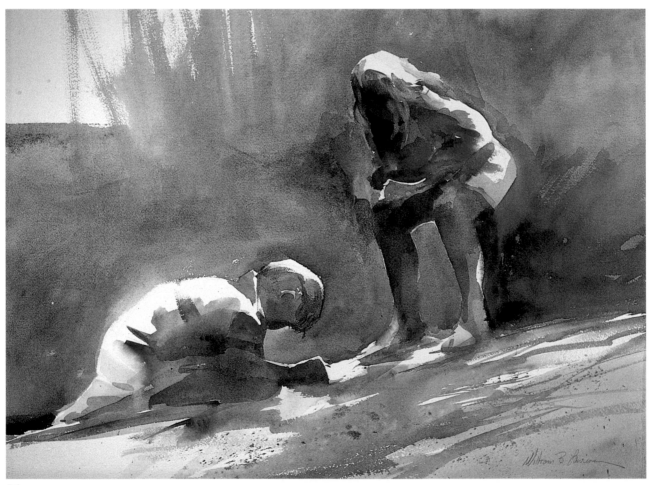

Discovery
15½" × 22"

Familiarity breeds understanding. I have drawn and painted my family so often that their shapes are easy. This painting of the children searching the rocks is a careful weaving together of light and dark values against midtones.

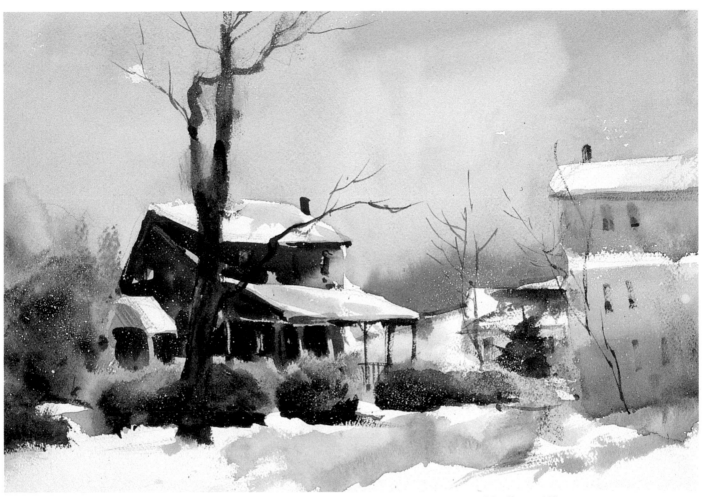

Marlboro, NJ
11″ × 15″

Snow-covered, dark houses are easy to express as light and dark against middle values.

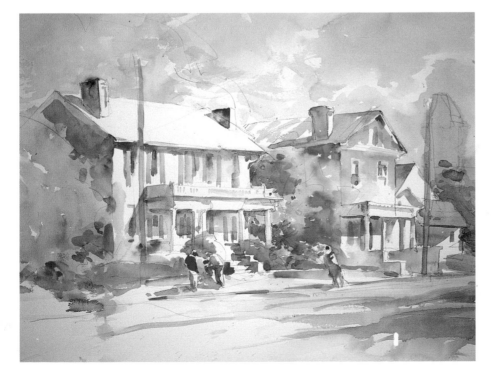

Augusta, GA
22″ × 30″

This demo painting was done on location in Augusta, Georgia, the week that I had the opportunity to play Augusta National. Judging from the color selections in the painting, I was still aglow with excitement.

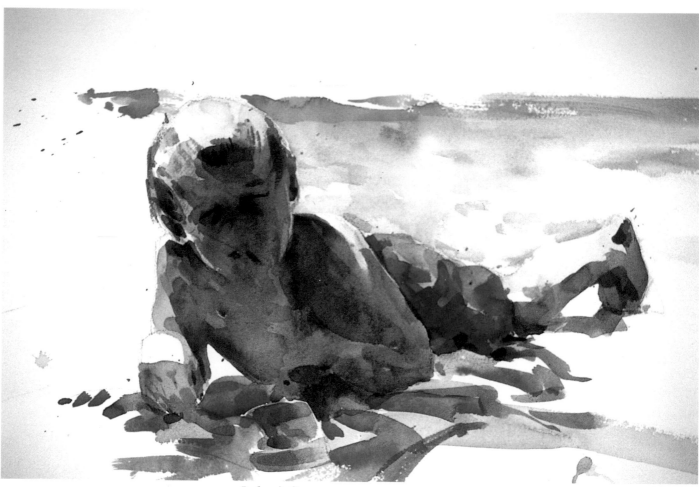

Joshua's Summer
20″ × 26″

Middle and Dark Values Against Light Values

This pattern of values is well suited for landscape painting. The sky, the source of light, is a very light value. All horizontal planes, since they are perpendicular to the source of light, are also very light in value. All planes that are parallel to the light source do not receive the full intensity of the light source and are middle values and dark values. So a typical landscape scene is middle values and dark values against light values. This is a generalization and should be taken as such.

Light, both natural and artificial, has the greatest effect on values. Take advantage of a sunny day and move an object or model to different parts of the room, taking careful note of how light creates each of the three value patterns described.

In natural light, most vertical planes turn out to be darker values than the horizontal planes. Therefore, it is easy to portray nature as middle and dark values against light. Joshua is lying on a flat plane, the beach, under the light sky—both light values. I simply handle everything but Joshua as one light shape and paint him as middle and dark values.

Sand Sifters
20″ × 26″

These children on the beach provided an interesting shape of colors. They are middle and dark against light.

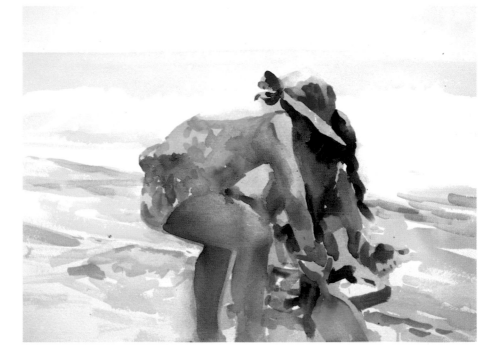

South Bristol, ME
20″ × 26″

While painting this subject I never thought of the value pattern. My interest was to show the variety of shapes and colors that I saw and felt. The painting is, however, middle and dark against light values.

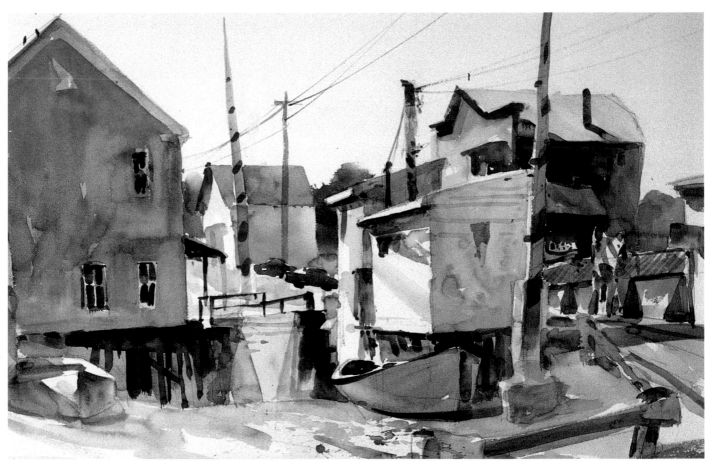

DEMONSTRATION: *Organizing Value Shapes*

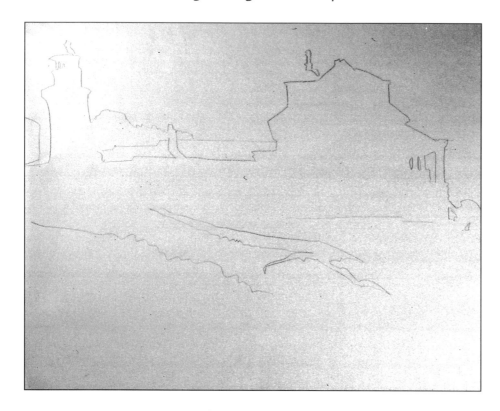

Step 1
A drawing should show evidence of your intent. I keep the drawing simple and concerned only with the large shapes.

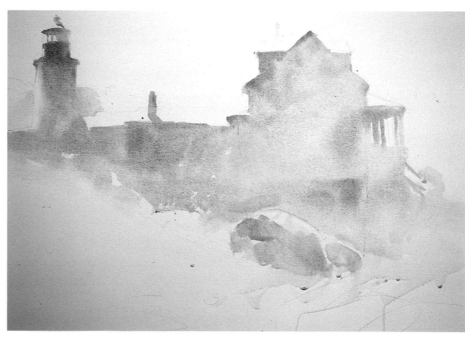

Step 2
My initial washes describe the shape of lighthouse, lawn, rocks and trees all as one thing. I take advantage of this step to also make the basic colors. In this case, I decide on cool pure tints accented with more intense warms on the face of the house.

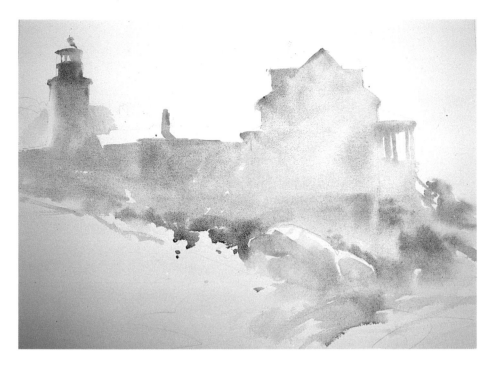

Step 3

Complementary colors are dropped in to contrast with the cool pure colors of the large house shape. It is not my intention at this point to add details. My only thoughts are of subtle color changes. I avoid strong value contrasts and hard edges, which would only serve to draw attention away from the large shapes and delicate color contrasts.

Step 4

I selectively add a few dark values along the edge of the total composition. These darks serve to complement the light that dominates the painting and identify the position of the light source. The trick here is to see how many details you can *leave out*. I add a very light neutral wash to the sky to define the roof edge.

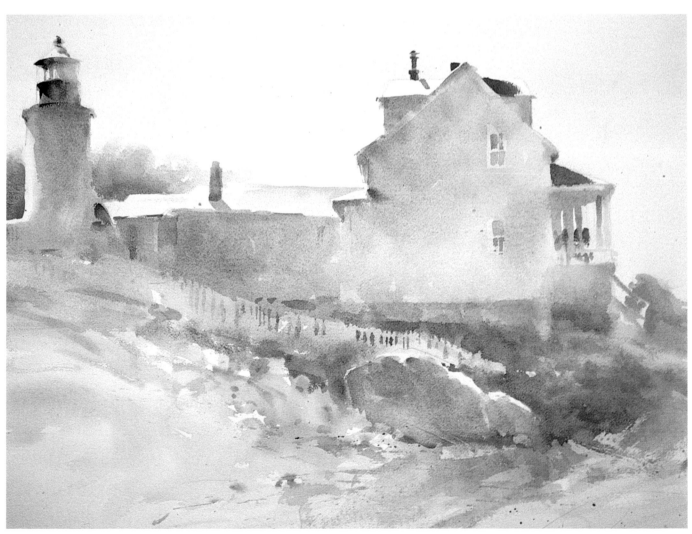

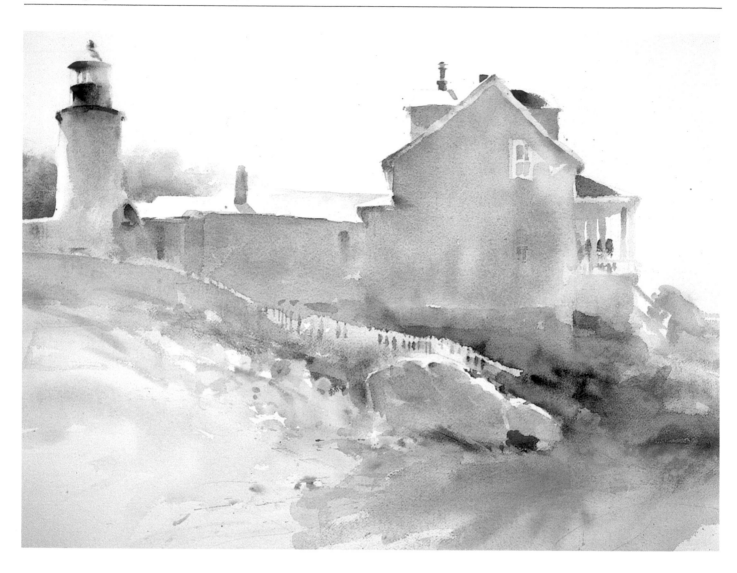

Pemaquid Point Lighthouse
20″ × 26″

One last wash of violet is necessary over the entire lighthouse shape to create a stronger feeling of sunlight.

On the Edge
20" × 26"

This was done from the inside edge of a cemetery looking out. There's something appealing about looking out of a cemetery, so I painted it. The shape of the trees and wall made a great pattern of middle and dark values. Beyond the wall there was light.

Remember:

- It is compositionally helpful to observe and design with value shapes.

- Value organizations can be altered to suit your objective.

- Reorganizing value patterns can identify focus.

- Reserve a greater value range for the focal point.

- Value shapes can be converted into color shapes.

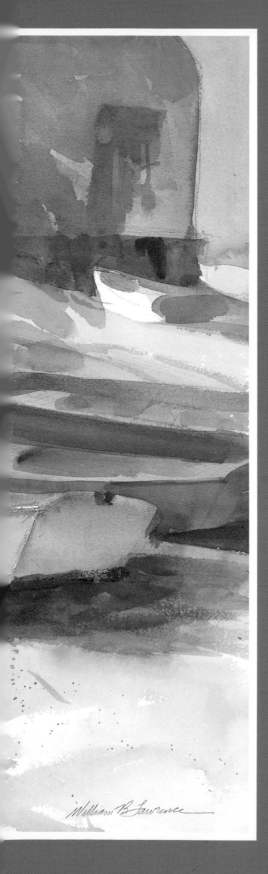

William B. Lawrence

Chapter Four

SHAPES AND COMPOSITION

A Two-Dimensional Activity

I often begin a workshop by announcing to the class that there is one thing on which we must agree: Painting is a two-dimensional activity. No matter how much you think about foreground, middle ground and background, the truth remains that the paper is flat. On it there is no deep space and there are no objects near you. Using aerial perspective, linear perspective or form description to create the illusion of depth or volume, while fun to achieve and requiring skill, is still only illusion.

The reality is that the paper is still flat and so are all the shapes on it. People categorize themselves as "realists"

Another misconception that inhibits our ability to think about and create great shapes is the idea that an accurate shape is a good shape.

when they are masters of deception. The true realist is the person who understands the necessity of making great two-dimensional shapes in a two-dimensional world.

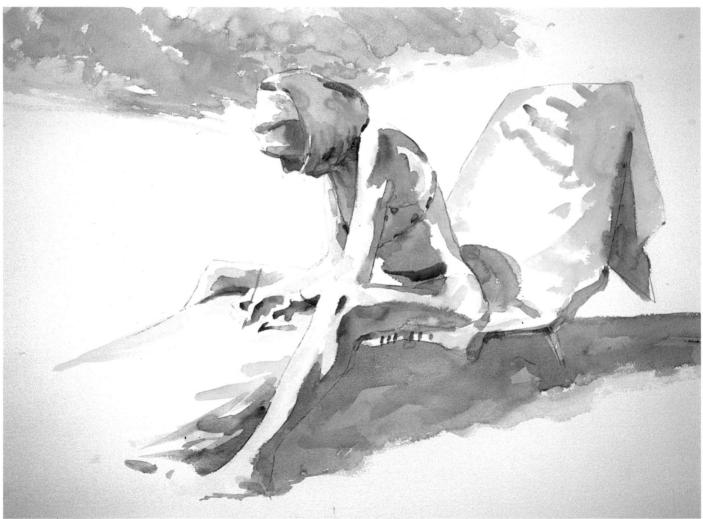

Shauna Writing
20" × 26"

This painting of my wife, combining business with pleasure, demonstrates the concept of simplifying numerous shapes into a cohesive pattern. The left side of the shape is mostly straight lines while the right edge is more curved. The shape of the chair, shadow and distant hill was also designed with equal care.

Be a Shape Maker

Ten years ago I went to an exhibition of the sculpture of August Rodin at the National Gallery of Art in Washington, D.C. The statue of Balzac immediately caught my eye. I was so intrigued with this piece of work that for an hour or so I walked around it, taking careful note of the relationship of one edge to its opposite edge. What was so interesting was that from any angle, what happened on one edge was always different from the opposing edge, but always in harmony. This experience taught me a great lesson in seeing and making great shapes. It may seem strange to be talking about Rodin (an artist whose work was presented in three dimensions) as a great shape maker, but Henry Moore once said that the definition of a sculptor is "a person who is interested in the shape of things." Other artists on my list of great shape makers are Degas, Matisse, Homer, Hopper, Milton Avery and Picasso. I have listed here only artists who are recognizable to most people. A complete list would take five hundred pages and include just about every good painter from prehistoric time to the present.

Another misconception that inhibits our ability to think about and create great shapes is the idea that an accurate shape is a good shape. Wrong! I have been told hundreds of times by students that they are going to take a drawing course to improve their painting. Don't get me wrong, but the idea of more accurate drawing solving painting problems is like taking dance lessons to improve your singing. While a drawing class may improve the accuracy of your shapes, it will not guarantee more beautiful shapes.

Abstract Shapes

Shapes are shapes and must not be confused with or slavishly tied to reality. The two abstract shapes above are offered to encourage you to place at least as much concern on the abstract design of a shape as you do on the accuracy of a shape. Turn your book upside down and look at the larger shape to see how abstraction and reality complement one another.

Making Beautiful Silhouetted Shapes

Enough theory; let's get down to business—how to make a great shape. First, we must define shape. A shape can be defined with a line or an edge. In watercolor, lines are generally made with pencil and define the outer edges of a desired shape. When using paint, shapes are defined with hue or value and it's the contrast that occurs at the edge that describes the shape. In both cases it is the silhouetted shape that is our goal and there should be no concern for the interior happenings of the shape.

I use the same approach to shape-making that I observed in Rodin's *Balzac*. That is, I want every edge of a shape to be significantly different from its opposite edge and in harmony with it. To achieve this, I draw an imaginary vertical line through the middle of a shape. If the left side mirrors the right, my chances of having a visually interesting shape are not good. While there certainly are times when symmetry is necessary, it is not very often exciting. In the examples given in this chapter, study the relationship of the opposing segments of each shape. If the east side is dominated by long curved lines, the west side will be made of short straight lines.

Care is taken to alter the length of each segment as your eye moves around the circumference of each shape. For purposes of simplicity I have suggested drawing an imaginary vertical line through each shape. The truth is that you should be able to bisect any shape at any point and find the opposing edges to be different and harmonious.

A note of caution: I have observed that many students have very interesting edges on the tops of their shapes, but boring edges on the bottoms. This is partly due to the flat plane of the earth from which most objects rise up. It is also probably the result of Mother Nature placing our heads on top. If you walked on your hands for a day, you would be much more aware of the interesting edges that occur on the bottoms of shapes. I suggest that you occasionally turn your painting upside down and treat the bottoms as the tops.

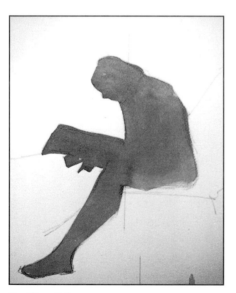

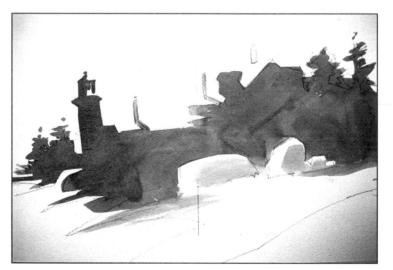

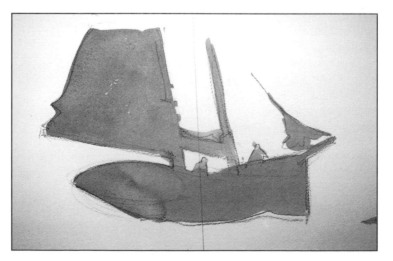

Exciting Edges

Great shape-making requires time and thought. You must be willing to edit shapes until they are perfect. I wear out more erasers than I do pencils when designing shapes. Look at these three shapes and study the relationships of opposite edges. Look for changes in the segment lengths, directions and detail. Time spent in making great shapes is money in the bank. When shapes work, 90 percent of the work is done. "A stitch in time saves nine," comes to mind.

Making Descriptive Shapes

Save yourself a lot of time by making shapes that, as silhouettes, describe the objects of the painting. Careful consideration of the details of the outline of each shape will carry the weight of 90 percent of your painting. You can accomplish this through good observation skills and by being committed to the idea that descriptive shapes are as important as great abstract shapes. The truth of the matter is that the two concerns go hand in hand. Careful observation of the outlines of most shapes offers the necessary varieties of lengths, directions and lines to create both descriptive shapes and interesting shapes.

As they say in Australia, a "walkabout" is informative and productive. When you approach a potential subject, take time to observe it from all directions. Undoubtedly, some views will be more descriptive than others. Taking time to seek out the best views at the beginning of your painting process prevents the later headaches of having to "make a silk purse from a sow's ear." The usual outcome of bad shape-making is an inordinate amount of time spent detailing the interior of the bad shape in the hope that it can be saved. The bad news is that no amount of polishing or detailing can ever save a bad shape.

There will certainly be times when your best intentions will not prove successful, either because of the shape itself or because the best view is obstructed by something, such as an ocean or fence. In such cases, you have two options: Give up or be creative. I suggest the latter. After all, this is a creative art. Notice that the option of using an uninteresting and nondescriptive shape was not considered. Good painters don't use bad shapes!

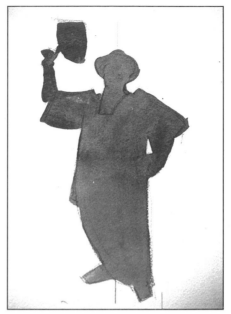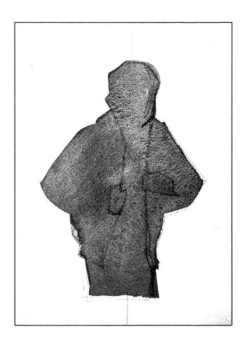

Descriptive Shapes

Look for a view that describes the subject and is visually interesting. The symmetrical shapes may describe, but they certainly lack the visual interest of a Rodin sculpture.

Inuit Guide
By Christopher Schink
26" × 40"

This handsome piece of work is an exquisite example of great shape-making. Dominated by curved edges and contrasted with a few that are straight, this shape can be bisected at any point and the edges are always in harmony. These seemingly simple shapes are the most difficult to attain—there is no room for error.

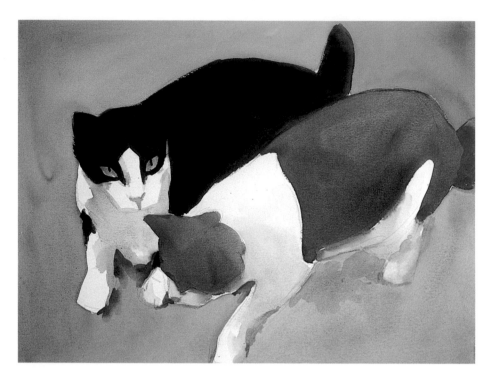

Sam and Heather
20″ × 26″

The family cats are great studies in abstract shapes. They even came in shades of black, gray and white.

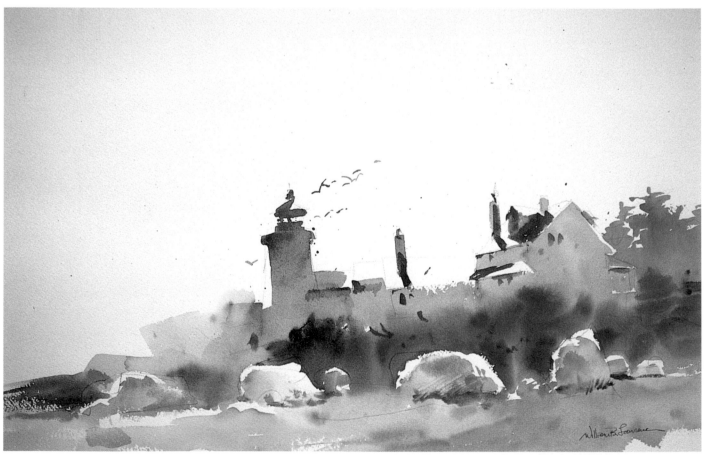

View of Pemaquid
15″ × 22″

The shape of the lighthouse is interesting, but let's face it, architecture is generally a collection of straight lines. I made the shape more varied here by including the distant trees, foreground bushes, and a suggestion of the ocean mist. Notice how the rocks, which are actually much smaller, are introduced to add variety to the often-forgotten bottom edge of the main shape.

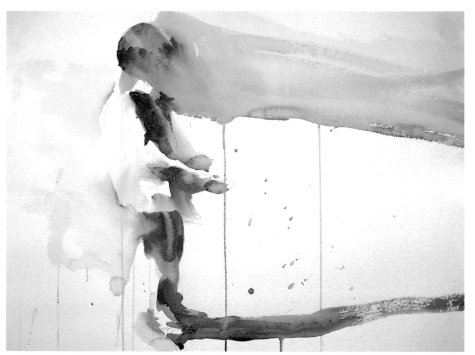

Josh in the Snow
22" × 30"

The brightness of the sun and the glare of the snow combine to obliterate many of the edges of Joshua. Notice how little of the actual edge is necessary to describe this shape.

Variety of Edges

Having become aware of the necessity to design expressive and visually exciting shapes and arriving at a point at which you can achieve this goal, you might think your work on shapes is complete. Wrong! But let me be the first to congratulate you on your accomplishments. You have joined an elite group of realists who know the necessity and satisfaction of making great shapes.

To reach your ultimate goal in dealing with shapes, you must now move to the edge—but not over. Every shape has 360 degrees of edge, and to achieve greatness you will deal with them all. When I was in college I spent hours looking at every segment of the edges of *Bather of Valpincon* by Ingres. Find a reproduction of this piece, the back view of a nude, and you will see a beautiful example of how an artist defines and treats the edges of a beautifully designed shape. Light against

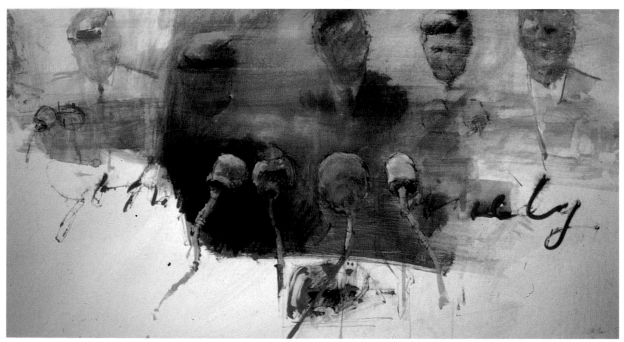

John Kennedy II
By Alex Powers
26" × 40"

Painters like Alex Powers do not depend on the cause and effect of nature to dictate treatment of edges. Notice how beautifully the overall pattern of the page is created and the care that is taken to vary the edges. Look carefully at the numerous portraits of JFK; each is a study in edge variations.

dark, dark against light, warm next to cool, cool next to warm, warm touching warm, cool touching cool, pure against neutral, strong contrast, mild contrast and no contrast are all evident in this painting. This is your goal.

Coupled with poor shapes, lack of concern for edges is largely responsible for unsuccessful painting. The inexperienced painter seems to strive for harsh edges, while the experienced artist seeks to lose edges, play down contrast, and vary edges as much as possible.

Contrast is the key word in successfully handling edges. When you look at an object, let your eye move along its edge and observe the contrasts. Some edges are lighter or darker

Great shapes should be descriptive of the subject, visually exciting, and varied along the edges in relation to the surrounding shapes.

than the adjacent shape. These contrasts are important for they make the object visually dramatic. You should also look for those segments of the edge in which there is little or no contrast to the surrounding shapes. Here shapes are allowed to breathe with the painting, shapes are locked into the painting, and bridges are created that allow the eye to move through the work. This is where your sensitivity to color and texture is most evident. It's the difference between the Texas brag and the understated humor of the Maine farmer:

Texas rancher meets Maine farmer.

TR: "This your spread, partna'?"

MF: "Ayuh."

TR: "Pretty nice place, but I tell ya it's nothin' like my ranch. I can get in my truck of a mornin', drive all day and never get off my property."

MF: "Ayuh, had a truck like that myself once."

There are many ways to minimize the contrasts of edges. Run an edge into an adjacent wet area and allow the colors to mingle. Break up an edge into pieces by spattering, scraping, blotting, gouging, sanding, or any other means you might invent. Edges do not have to be obliterated to appear lost. By simply matching values where two shapes meet, edges can remain sharp but have little contrast and thus become bridges where the eye is allowed to flow uninterrupted.

To summarize, great shapes should be descriptive of the subject (if you are working representationally), visually exciting, and varied along the edges in relation to the surrounding shapes.

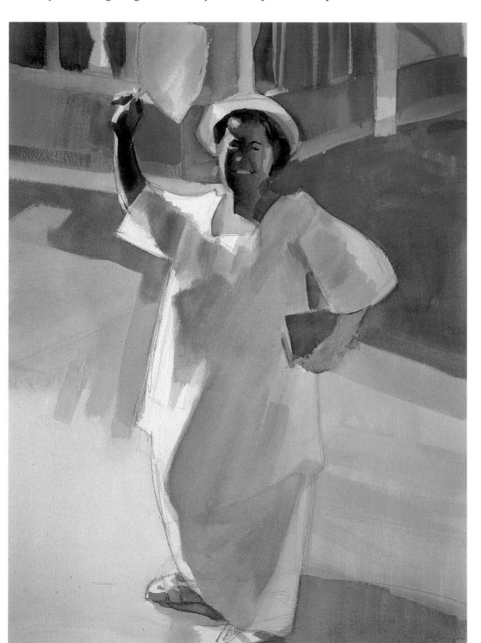

Island Woman
30" × 22"

Study the relationship of values and colors along the edge of the figure. Notice the places where the figure is lighter or darker than the background. Also important are the places where values and colors are the same as the background. It is where edges are lost that shapes are locked into the painting.

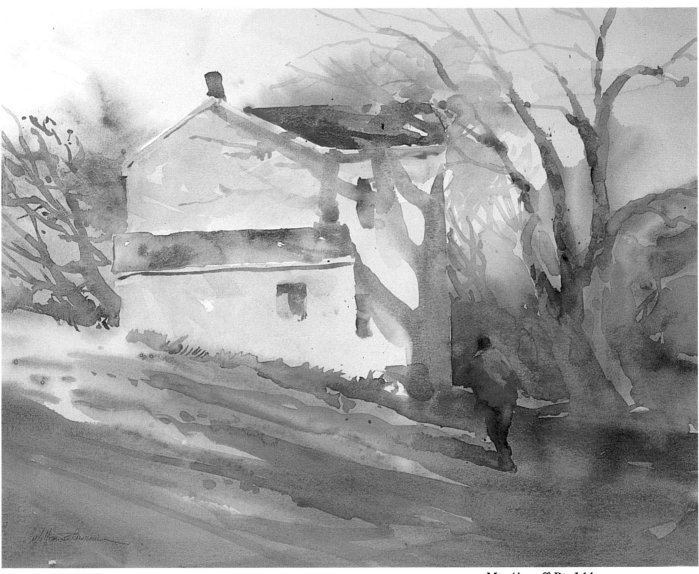

Mt. Airy off Rt. 144
20" × 26"

This painting employs the same concern for edges, but here I blurred edges using a wet-into-wet approach. The effects of light and shade provide a perfect reason to play the lost and found game with edges.

Remember:

- Painting is a two-dimensional activity.
- Great shapes are the result of a concern for edges.
- Accurate shapes are not necessarily great shapes.
- By bisecting shapes you can compare the opposite edge relationships.
- Silhouetted shapes can describe the content.
- By varying edges, shapes are interlocked into the painting and visual excitement is added.

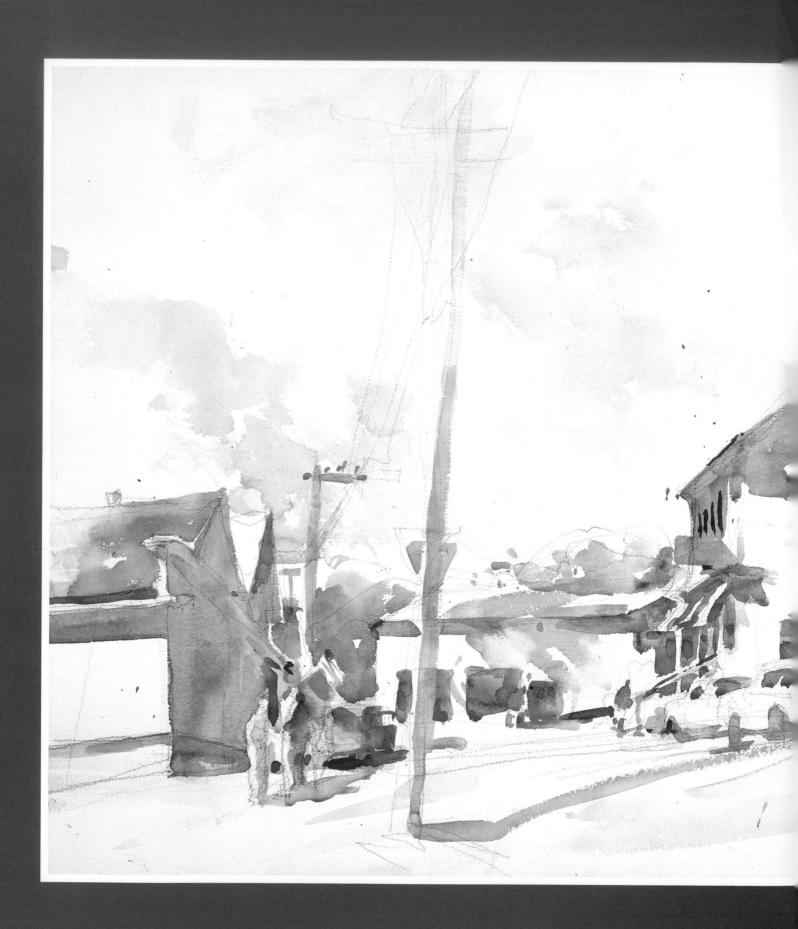

Chapter Five

Composing With Spotlight or Floodlight

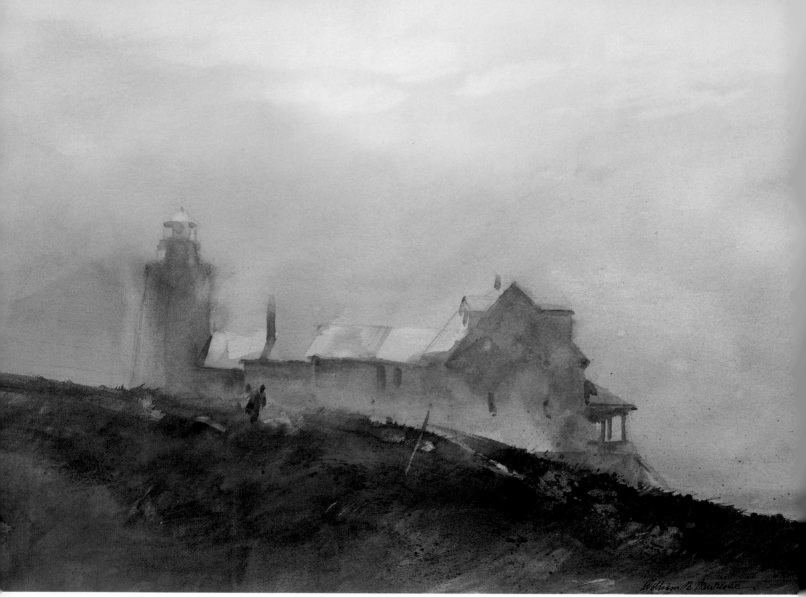

Light at Pemaquid Point
20" × 26"

There are days, sometimes many in a row, when fog lies along the Maine coast and transforms colors, values and textures into a symphony of softness. Subtlety is the key word on these days.

Painting the Light You See

This book is specifically written to give you an approach to designing paintings using lighted shapes and shaded shapes. The truth is that everyone who paints representationally relies on light. Without light you can't see — not the subject or even the paper on which you work. There is, however, a large difference between going out to paint what you see and going out to paint the light you see. Light comes in many forms. Light has color and differing intensities; it can be direct or reflected; it can define local color, obscure local color and alter local color.

Becoming acutely aware of specific lighting conditions can make you a better painter. Before you begin to paint, take time to observe the color, intensity and other qualities of the light. Ask

yourself whether it's warm or cool, clear or hazy, direct (like a spotlight) or filtered (like a floodlight). One of the tricks I use to identify color is to look at colors with my peripheral vision. I have no idea why this works,

There is a large difference between going out to paint what you see and going out to paint the light you see.

but it does. Know that every color in nature is reflected onto every other color. A clear blue sky should be evi-

dent not only in the sky but throughout the entire landscape. Being sensitive to light will not only help with your painting, but will turn on a whole new world of color that will enrich your life and make you the envy of those not so blessed. And then, when the inevitable question is asked, "Do you see those colors?" you can raise your eyebrows, look the questioner in the eyes and respond, "Don't you?"

Spotlight

Too often, less experienced painters, when painting on location, use the spotlight approach. Each object is defined by its light side, shadow side and cast shadow. There is much to-do concerning where the sun is and how it describes form. The problem with this approach is the resulting painting places too much emphasis on isolated objects and not enough on the overall patterns that are created by a single light source, the sun. You have to remember the sun is ninety-three million miles away. It illuminates the entire atmosphere of half the earth and is not directed, like a theater spot, at individual objects.

We perceive objects as spotlighted on days when the atmosphere is crystal clear. On these days everything seems sharply focused and hard edges abound. Mountains ten miles away, a house fifty yards away, and the person you're talking to all have the same crisp clear edge. It is essential on these days that you find the bridges, those edges of nearly the same value, color or texture that will lock these shapes into the painting. Cast shadows often provide the connections you need. Look for cast shadows that link darks together.

To this point it may sound like I dislike clear, sunny days. Nothing could be farther from the truth. What I am saying is that you should design and paint the pattern of light and shade on beautiful sunny days, and forget the object-by-object form description.

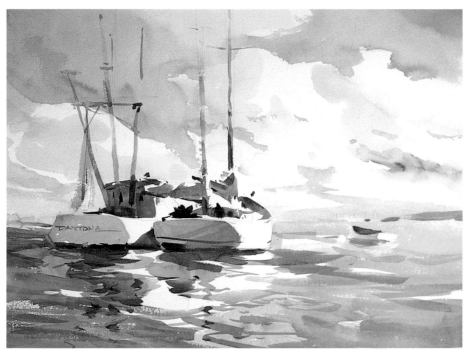

Florida Reflections
22″ × 30″

The sky, water, and lighted side of the boats are kept close enough in value to make all three areas read as a unified expression of sunlight. The shape of shade is the right size, shape and value to convey the effects of clear light.

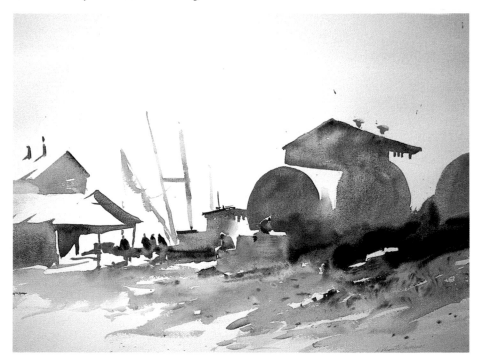

Ft. Myers, FL
20″ × 26″

When the sun is bright and the atmosphere clear, value contrasts are strong and edges are crisp. My class questioned my selection of subject matter. Had I been painting the tanks and buildings, I would have been skeptical also, but all I could see was the beautiful pattern of light and shade.

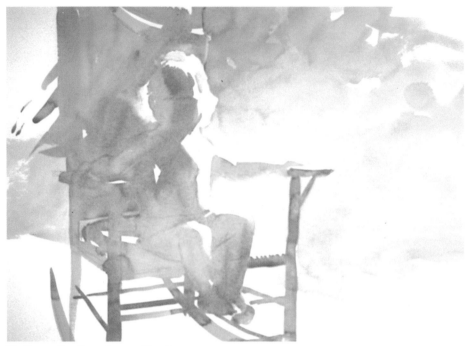

Carly on the Farmhouse Porch
20″ × 26″

It is not always necessary to express strong sunlight with extreme value contrast. Think about those times when sunlight is so bright as to be blinding—when light obscures edges rather than defining edges. The quality of light in this painting of my daughter seems much brighter than the light of *Ft. Myers, FL* or *Florida Reflections* on the previous page.

Value Contrasts With Spotlight

I often hear, "the stronger the light—the darker the darks." It sounds correct and logical, but it's not necessarily so. The paintings I have seen that best express strong light don't generally use extreme value contrasts, but very close

Look, be sensitive, and be amazed by what you observe.

values. I recall a student in Maine who did a painting of the sun. She managed to absolutely nail the subtle value contrasts between the sun and the sky to the point where I had to squint to look at it. I have never had that experience with a white to black portrayal of light. What you must remember is that on an extremely bright day the light that creates seemingly black shadows is reflecting off everything and back into the shaded areas. This lightens the value of the shadows and reduces the

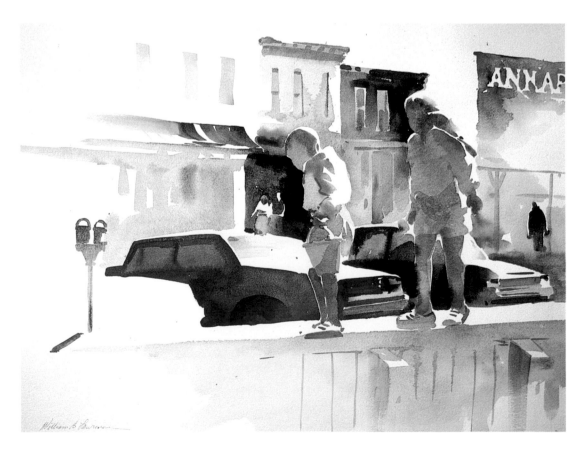

Tight-Wall Walking in Annapolis, MD
20″ × 26″

This is one of those times when I expressed light by painting only shade. The reflective surfaces of automobiles, the absorbing surfaces of the kids' clothing, walls and buildings are all surfaces in direct sunlight and left as white paper. All color changes are made in the shadow shapes. The strong value contrasts and the hard edges combine to express strong light.

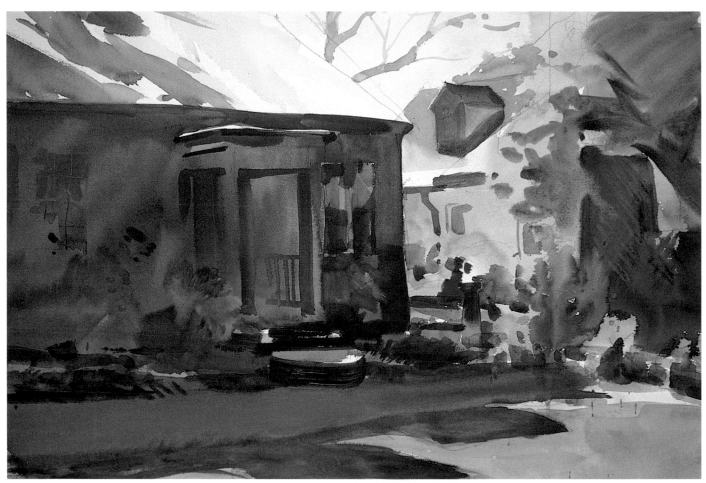

Kinston House
20″ × 26″

value contrast. The exception to this is when you're in a canyon of vertical planes where reflection is minimal, such as midtown Manhattan, or when the light source is very weak, such as a candle or 40-watt light bulb. In these cases the darks are very dark, because the light is not strong enough to reflect.

These observations are not absolutes, for you will certainly find other exceptions, but I point them out to encourage you to be a student of light, to cleanse your mind of preconceptions and look at light and the effects it creates. Light is not always warm, and shade is not always cool. Look, be sensitive, and be amazed by what you observe.

Color is an equal and essential partner when portraying light. It is not enough to squint your eyes and see only values. You must look into the shadows and identify the colors that are there. Don't look for formulas or short cuts to tell you what colors shadows should be or always are. Look for the warm colors in the shade and the cools in the sunlight. It takes some practice to allow your eyes to see shapes, values and colors. Take the time!

Floodlight

The quality of light from a floodlight differs from that of a spotlight in significant ways. The floodlight comes more from an overhead direction, produces softer edges and reduces value contrast.

When painting landscapes I prefer to compose with a floodlight in mind rather than a spotlight. I think of light as something created by the sun illuminating the earth's atmosphere, filtered and falling gently to the earth's surface, like snow. Except for those few hours of the day, dawn and dusk, when the sun is very low and the sides of objects are directly lighted, this perception is both useful and accurate. The sun is a floodlight that illuminates an entire segment of the earth—not a spotlight that moves from house to tree to figure like the lighting in a stage performance.

By thinking of the sun as a floodlight, you'll benefit from different perceptions of light, which I believe will improve your painting. The first of these is that floodlights produce a soft-filtered light that softens edges. Where edges are softened, the eye moves gently from shape to shape, color to color. One only has to look at the paintings of Turner to see how unimportant hard edges are to a painting. Razor-blade edges, the result of spotlighting, stop the eye's movement, isolating shapes and colors, and giving the perception that the objects exist in a vacuum. Some of the worst paintings on earth are hard-edged, high contrast portraits of houses.

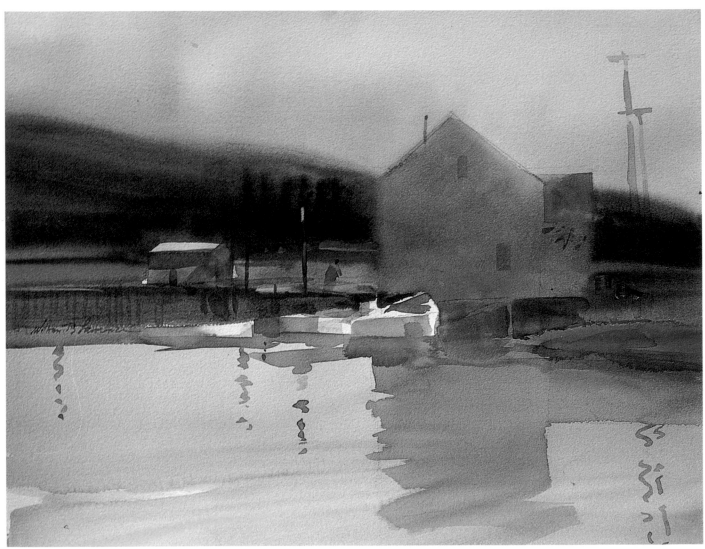

South Bristol, ME
20" × 26"
Collection of Alex Powers

The effects of thinking floodlight rather than spotlight are quite significant. Edges are softer, value contrasts are closer, and color takes on a more important role. This painting was done from a photo taken on a sunny day. I translated the spotlight effect of sunny day into a floodlight effect of a hazy day. In so doing, subtleties of value, color and texture contrasts are predominant.

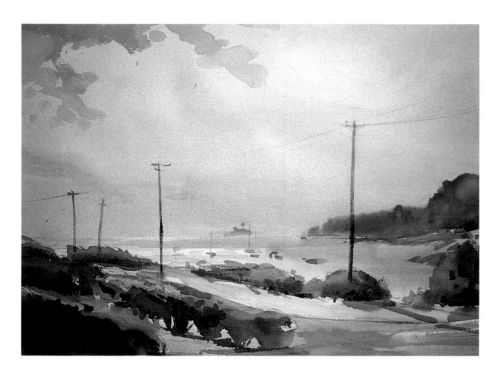

Long Cove
20″ × 26″

I used the white hazy light of August to create a floodlight effect for this painting. As an alternative to creating atmospheric images that are the result of moisture, you can obscure distant shapes with light. In other words, I was not looking through water, I was looking through milky light.

Value Contrast With Floodlight

Floodlighting, in my mind, is a softer filtered light that reduces value contrast. The truth is that all light is filtered. After all, the light of the sun has to travel through two hundred miles of the earth's atmosphere. Artificial lights are not exempt from the effects of the billions and billions of molecules that make up our atmosphere. I sometimes encourage students who are having difficulties seeing the effects of the atmosphere to imagine they are painting underwater. The earth's atmosphere is nothing more than very thin water, so this approach often makes a difference.

An obvious example of the effects of atmosphere and of the floodlighting idea is a foggy day in Maine. I once had a workshop group in Maine that had a chance to see firsthand how fog and filtered light reduce value contrast and soften edges (ten straight days of it). While I cannot report that there were no complaints, there was an unusually high number of great paintings

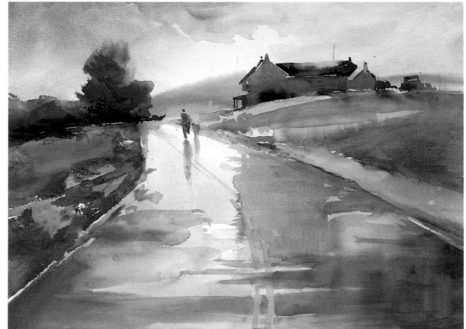

Mountaindale Road
20″ × 26″

Instead of looking for a perfect, clear sunny day for painting, take advantage of inclement weather. On just such days you will find the beautiful effects of floodlighting. When else will you have the chance to see reflections on a road? Only with such soft-filtered light can you use bilious colors and have them look natural.

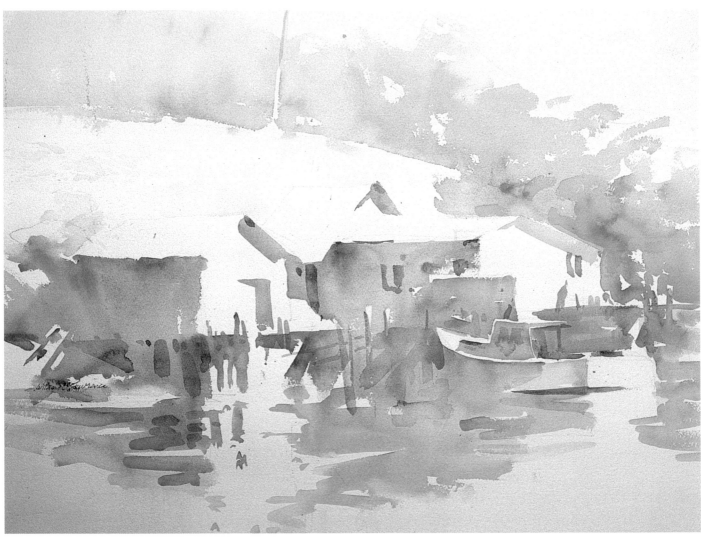

Lobstermen's Coop
20″ × 26″

With floodlighting, value contrasts are close. Instead of the value contrasts changing from white to black, I think of reducing the contrasts from white to *slightly* darker. The effect of these close value contrasts is a feeling of brilliant light that reflects off everything and keeps even the value of shadows light. I also take care to lose edges, which helps to give the impression of soft-filtered light.

produced during this time. For those who would like this opportunity, I cannot guarantee such luck as this group had, but certainly any two-week stay along the Maine coast will provide at least one day of rich, thick fog.

You don't have to paint in fog to understand the effect of floodlighting on value contrast. Just remember that no matter how clear the day, you are always seeing everything through veils of illuminated atmosphere. Using this approach you will know that it isn't possible to see the extreme values of white or black. When you reduce value contrasts your paintings are filled with atmosphere, and color plays a much more important role. Even the most subtle of colors suddenly become visible and exciting.

Light From Above

Another effect of floodlighting, or the idea of the sun illuminating our atmosphere, is that light appears to fall from above and settle on the tops of things. The best way to understand this idea is to think of light as snow. On what surfaces does snow collect? Wherever you know snow would collect is the same surface where light collects. Vertical planes don't hold the snow. The more horizontal the plane the more snow accumulates and the lighter that surface appears. The same is true of light.

With this in mind, a lawn appears not as green grass but rather as a horizontal plane collecting light. The same is true of a black roof, a figure's shoulders, or the rail of a boat. Vertical planes, upon which the snow (light) cannot collect, retain more local color and appear darker in value. I say "appear darker" for in fact the shadow side of objects does not get darker, but only appears darker due to the contrast of being seen against the light. I will go further and say that when there is strong light, what we identify as being shadow is not darker than before the light was turned on, but actually a little lighter. So, don't paint the lighted side of an object lighter and the shadow side darker than local color, but paint the lighted side lighter *and* the darker side lighter.

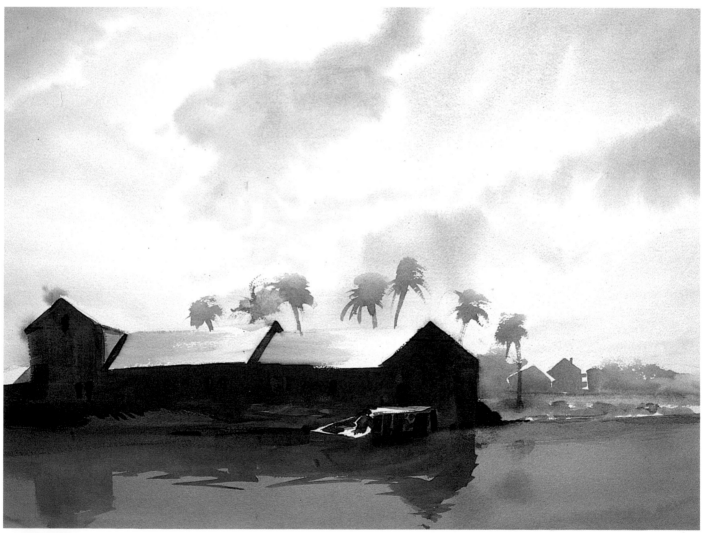

Florida White
20" × 26"

This collection of shacks is the same subject I used in *Florida Orange* in chapter eight and even on the same day. The difference is a change in emphasis on light. *Florida Orange* is about the color of light, while *Florida White* is about the intensity of light—that intense light that falls from above like snow and obliterates the color of everything upon which it falls. In these cases, my only thoughts are of how the falling light affects the flat planes it settles upon.

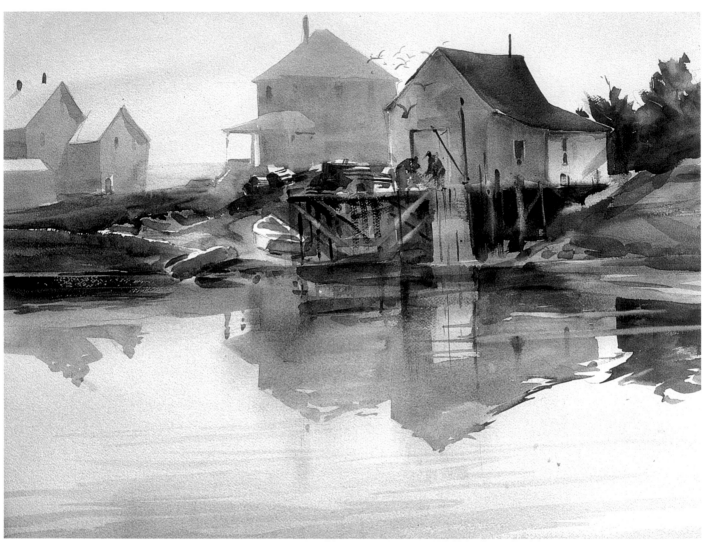

Little Beach
20″ × 26″

One of my favorite painting locations, this beach provides an ever-changing supply of atmospheric conditions. The combination of interesting shapes, a reflective tidal pool, and the various moods of Maine has given me many hours of exciting painting. The mist of the day, coupled with the neutral gray of the weathered wood of the fish houses, evokes a symphony of subtle color changes.

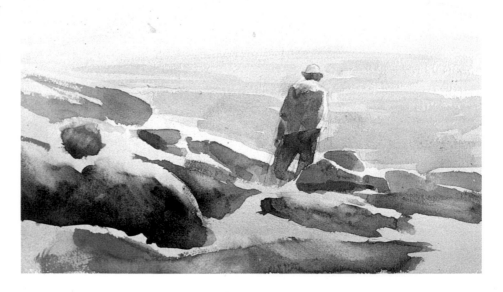

At Pemaquid Point
11″ × 15″

A fun approach to designing with light is to describe the top planes of objects as white and the vertical planes as dark.

DEMONSTRATION: *Painting the Effects of Strong Light*

Step 1

Done from a photo, this painting is a celebration of friendship and light. The quartet includes, from right to left, Fred Wiley, Don Stone, yours truly and Dr. Jim McDonough, with whom I spent a week of painting on Monhegan Island, Maine. The drawing is a careful outlining of the unique gestures of each personality.

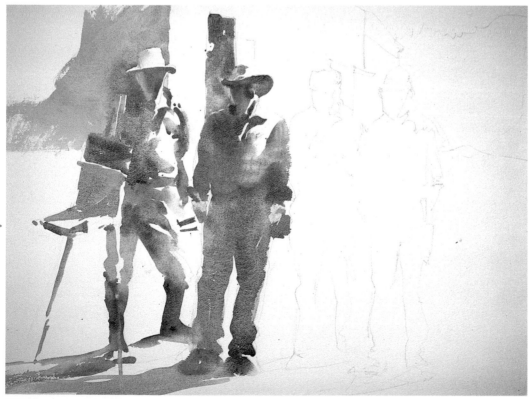

Step 2

The initial colors are designed to describe the pattern of shade. I am careful to relate the figure shapes with the adjoining shapes of building, window and cast shadows. Color changes are a blending of local color and reflected light, with a minimum of value change. Notice the treatment of edges as I take every opportunity to bridge the positive to the negative.

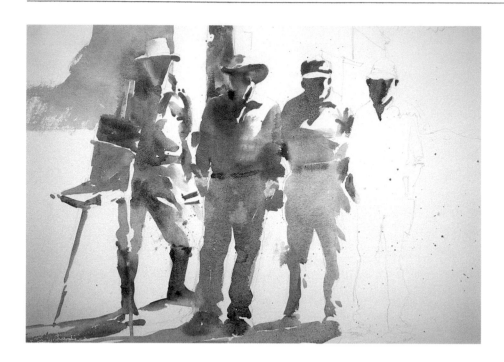

Step 3
As the unified shape of the group develops from left to right, my thoughts are of color, temperature and intensity changes. I avoid an exact repeat of color.

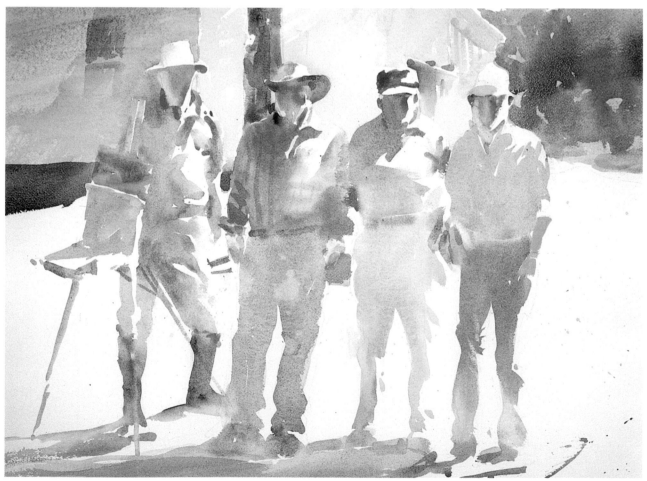

Friends of Monhegan
20" × 26"

The placement of two slightly darker areas, at the left and right of the group, are added to enhance the effect of strong light.

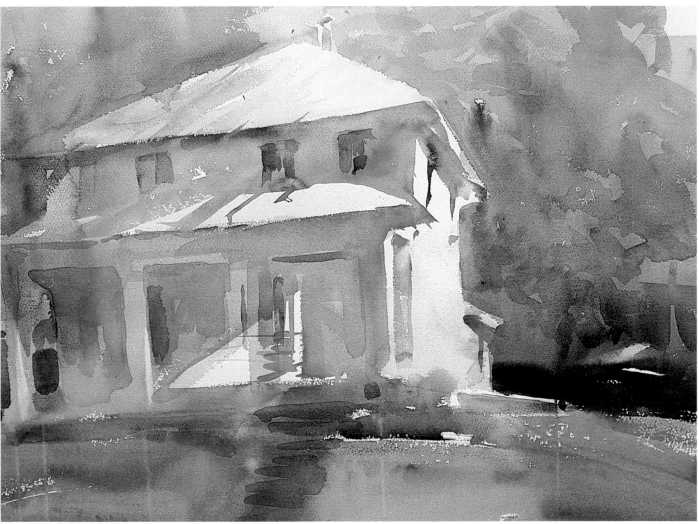

Oak Hill, NY
20" × 26"

Remember:

- Look for the color of light and remember it affects everything it touches.

- Spotlights create strong contrast of values.

- Spotlights make hard edges.

- Light reflects and affects all colors and values, even in shadow.

- Floodlights create subtle value contrasts.

- Floodlights make soft edges.

- Floodlights give the effect of snow that lies on the tops of objects.

- Shadows are not darker when the light is strong, the lights are lighter *and* the darks are lighter.

Houses don't hold much appeal for me. What did turn me on was the clear, soft light which fell upon a white house and the autumn foliage. To achieve this effect, I painted the shadow portion of the house, the lawn and the trees a similar value, as if they were bathed in the same light, and kept the white of the house pure.

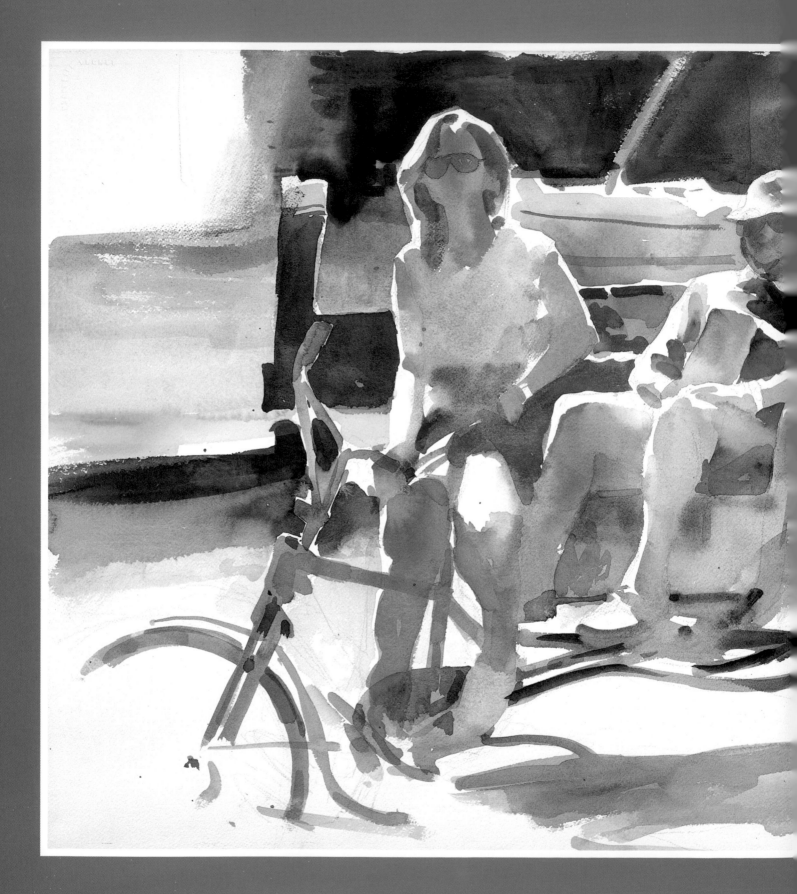

MAKING COLOR DECISIONS

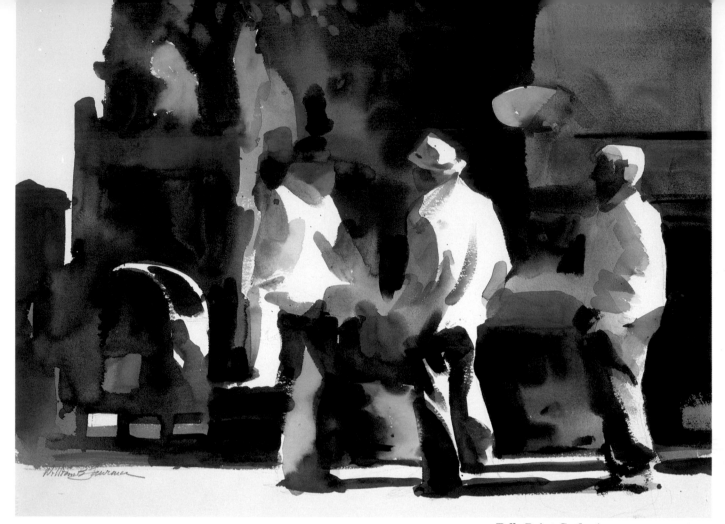

Fells Point Gathering
20" × 26"

"Seeing" Color Relationships

I certainly do not suppose it possible to cover the scope of color in a single chapter or even in a one-thousand-page book. What I will do is share some ideas that will provide a foundation on which you can build a more rational, as well as expressive, approach to making color decisions.

At the most basic level, color is not complicated. Two colors are placed side by side in a painting. You have the choice of either making them different, in a limited number of ways, or of keeping them similar. There are certainly times when one choice is better than the other. Poor color relationships happen when the painter doesn't consider the choices. Unfortunate are the painters who paint exclusively in local color. They see the sky as blue, the grass as green, the house as white, the barn as red, etc. I use the word "see" incorrectly, for in truth they don't see anything. Rather they go to their "memory bank of color general-izations" and select a color that was stored away as toddlers. It's hard to break old habits.

To improve your ability to see col-ors correctly, I suggest you try this agenda. Never begin by asking the question "What color is it?" The an-swer will be a one-word generaliza-tion—too narrow in scope to be of value. First determine what value it is—somewhere between white and black. Then determine what tempera-ture it is—either warm or cool. Third,

Poor color relationships happen when the painter doesn't consider the choices.

ask what the intensity is—somewhere on the scale from pure, intense color to neutral gray. The last question, which you probably will have answered by this time, is "What color is it?" So instead of saying the tree is green, your response will be, the tree is a dark, warm, neutral green. You might also answer light, cool, pure green. This ap-

When value wins, color loses. This is not to say that color choices are not important. Value paintings should have beautiful color, but this painting's shapes are visible because of their light values against dark values.

proach arms you with much more specific information.

Having once, with sensitivity and intelligence, identified the color of a shape and placed it on the paper, a series of decisions is set in motion. You will want to place a color next to the first which will enhance both. Keep in mind that contrasts are complementary. As dark values make an adjacent light appear lighter, so also a warm complements a cool, a pure complements a neutral, and any hue complements its opposite. Your choices are limited to value, intensity, temperature or hue changes. In this chapter, I talk about each choice separately.

Light Next to Dark

An arrangement of great shapes is essential to great painting. Once you have designed these great shapes and drawn them on the page, the next requirement is that you make them visible. I know this sounds obvious, but believe me, it's not. I have seen hundreds of paintings in which contrast of values, colors and textures have been reduced to an indistinguishable mush. It is not necessary to speak loudly, but it is essential to speak clearly.

One approach to making the shapes and patterns of our paintings visibly clear is separating them by value contrast. When you do so, color takes a secondary role. You need only identify what value to make a shape. Forget the local color and establish the value contrasts that will make the shapes and composition clear. It isn't necessary to use color to paint; we compose with graphite all the time. The Bradywine River Museum exhibits some of Andrew Wyeth's latest watercolors, which are done with a warm neutral gray and black ink. The paintings work because of the shapes, composition and draftsmanship; local color is implied. Since nature's colors tend to be warm and neutral, Wyeth's palette is effective. It would not work if the goal was to express the brilliant colors of a flower market.

Value painters paint and observe with their eyes squinted. They can generally be recognized by the presence of crow's feet extending back to their ears. I have overheard my good friend Don Stone instruct his classes to paint with "half-closed eyes and a wide open

> *A declaration of intent is important to your artistic development.*

mind." The impact of value painters' work is in the contrast of values and texture. The best of the value painters do not pretend to be colorists. They

avoid strong color that compromises the effect of value contrast. This makes sense, for no amount of color can compete visually with the effects of strong value contrast.

A declaration of intent is important to your artistic development. One of the things I admire about Alex Powers is his dedication to value and texture. He has no pretense or concern with color. Make your own declaration. It will make you a better painter and a happier person, improve your marriage, and put a bounce in your walk. You'll hear better, see more clearly, and be more enjoyable to be around.

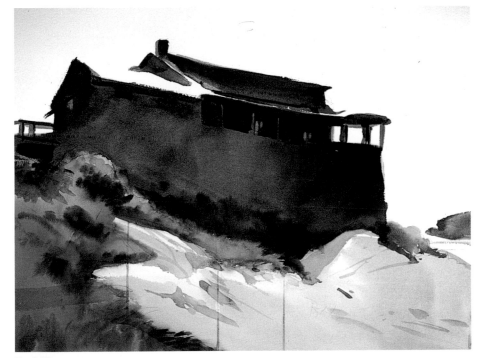

Red House
20″ × 26″

The so-called Red House of Monhegan Island has been painted thousands of times because of its interesting and varied shape. A shape like this can be interpreted in value or color. Because my infatuation was for the light, I did this painting with strong contrast of value—dark against light.

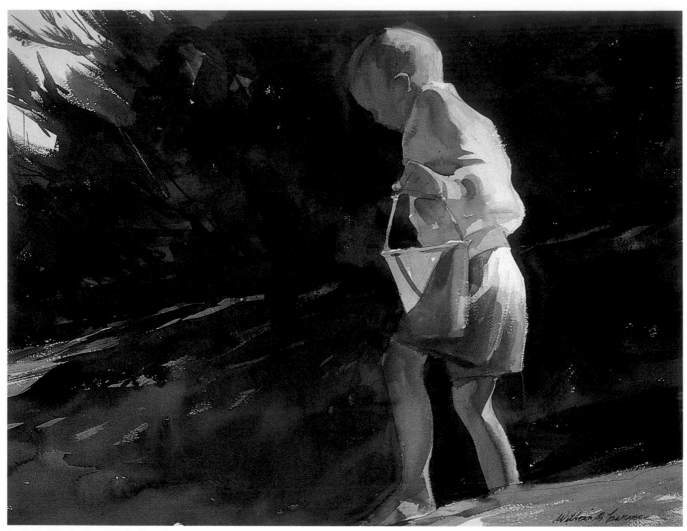

Joshua Exploring Little Beach
20" × 26"

Nothing is more emotionally appealing than children. I used value contrasts to express the light that defined my son's careful walk along the rocks.

Warm Next to Cool

Alternating the temperature of shapes from warm to cool is a simple and effective way of making the shapes of your painting read clearly. With this approach, as with any color-based approach, it is not necessary to rely on value contrast. It is not even advisable to allow value contrast to override the subtle beauty of temperature changes. Alternating temperatures is not limited to juxtaposing shapes, but can be used to enhance shapes by layering cool colors over warm and vice versa (more on this approach to follow).

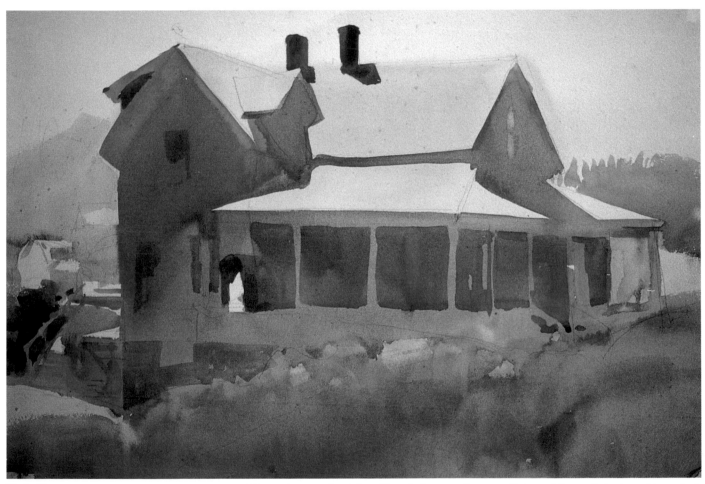

High Noon
15½" × 22"

My total reason for doing this painting was the warm light and the cool shadows. If you look closely, you will see that any surface that received light was painted in warm colors. Those surfaces in shade were painted exclusively with cool colors.

Pure Next to Neutral

It has been my experience that all students generally have to grow along the same route. First is the understanding of seeing and painting in values, followed by temperature and hue, while awareness of changing intensity relationships comes last. The next time you go out to paint, look at the subject and instead of identifying shapes by value or color, seek out the most intense color. Distinguish the range of intensities from the most pure to absolute neutral, then make a painting that emphasizes an intensity scale. You will be dazzled with the results.

Off Springmaid Mountain
20″ × 26″
Collection of Gerald McCue

I find mountain landscapes difficult because they demand aerial perspective solutions. In this case, I solved the problem by reducing value and thinking only in intensity relationships.

Pulling Together
22″ × 30″

I could not resist the title for the piece, since it portrays newlyweds living on Monhegan. The orange slickers offered a perfect chance to play pure hues with near-neutral intensities. After establishing the orange, the game was to keep all other hues varied in value and intensity.

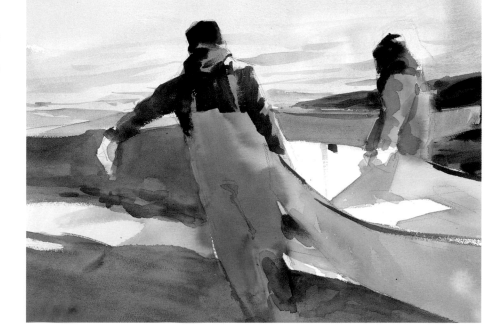

Picnic Flowers
20″ × 26″

Flowers are a natural subject for looking at color intensity harmonies. Pure flowers against neutral intensities.

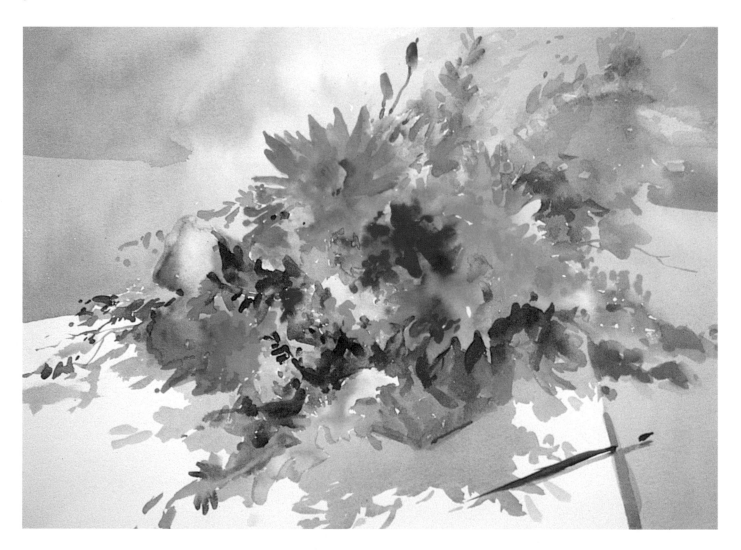

Hue Next to Hue

I'm crazy to include this segment on color relationships, for while placing one color next to another is essential to making paintings, it is so infinite in possibilities that generalizations are difficult. Imagine how many thousands of colors exist of the primary, secondary and intermediate varieties alone. To paint only with pure hues—red, yellow, blue, green, orange and purple—without the modifying qualities of value, temperature and intensity, is to paint like a child.

If you believe, as I do, that depth of knowledge is proportionate to breadth of experience, then it is important to know what it feels like to paint with hues only. For your initial painting I suggest you divide your palette into three categories: light values—yellows, yellow-greens and oranges; middle values—reds; darks—blues, greens and purples.

Working from a value pattern that clearly defines the shapes of light, middle and dark values, paint the light value shapes with the pure pigments from column 1, middle value shapes from column 2, and dark value shapes from column 3. The resulting painting may be unlike anything you have done before. Before you decide never to try this again, look at the paintings of the German expressionists, the Fauvés and Vincent Van Gogh. If you like the results, you may have just taken a major step in your art development, from "watercolorist" to "painter."

The point of all this is to encourage you to use the watercolor pigments, when appropriate, in their full intensity. Diluting the pigments with water is not mandatory. The effect of water on pigments is a reduction in intensity and lightness in value. How often has

My present palette is divided as follows:

1. Light pigments	2. Middle pigments	3. Dark pigments
Winsor yellow	turquoise	thio violet
thalo yellow-green	viridian	ultramarine blue
new gamboge	permanent rose	Winsor violet
raw sienna	Indian red	Winsor blue
yellow ochre	cobalt blue	Winsor green

Fall Foliage
5" × 7"

This color sketch is a prime example of shapes that read because of hue next to hue. It was done in response to an October in New York state. The subject matter often gets in the way of the most obvious expression of our reactions to a place. No one ever went to Vermont to see maple trees, but thousands go annually to marvel at the colors.

someone compared your painting to your palette and said, "Your palette is beautiful!" The reason the palette is more exciting is that the pigments have not yet been mixed, glazed, blotted and otherwise tortured to the point of nondescript identity. The pigments, as we buy them, are as rich and beautiful as they can be. Not to use this portion of the spectrum is to limit your vocabulary. It is possible to paint with a limited palette, but success will be in spite of the limitations and not because of them.

Here are some practical applications of hue next to hue:

- When making darks, use pure dark pigments instead of mixtures of brown gravy.

- Use gradations of colors from the color wheel to create contrast and harmony within a shape. For example, when painting green shapes, such as foliage, paint from blue to blue-green to green to yellow-green to yellow. With this gradation you will have the contrast of blue to yellow and the visual excitement of the sequential change of numerous colors.

- Colors close in value can be altered randomly and will be harmonious.

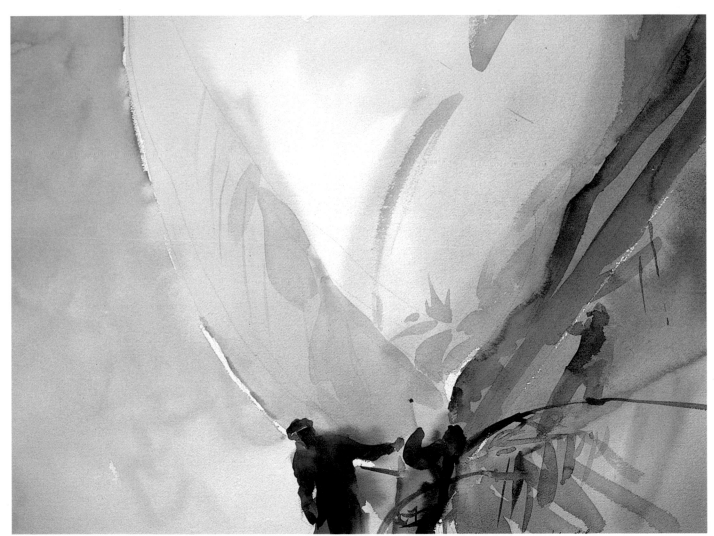

Skipjack Jib
22" × 30"

Trying to show the billowing quality of a sail was achieved, after many attempts, by reducing the value contrasts and making nothing but color changes. If you want a challenge filled with fun and frustration try painting with only hue changes.

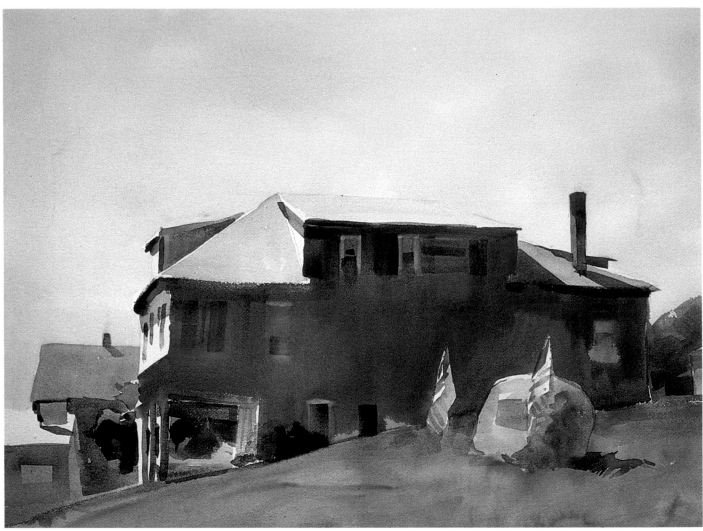

New Harbor, Maine
20" × 26"

Applying Pigments

As to how pigments are applied to paper, watercolorists generally fall into two categories: glazers and minglers. Glazers work in sequential layers of pigments. This can be done using a wet-over-dry technique or dry-over-wet technique. Minglers are generally less patient and prefer to mingle pigments or change colors along a wet edge.

Many of the colors achieved in our paintings are the result of not just the pigments used, but also when and how they're applied. In this case, the shape of the house began with a dark ultramarine blue base. While still wet, relatively dry applications of Indian red, cadmium red and permanent rose were applied. The quality and depth of color gained cannot be delivered in any other way. The same approach was taken to the foreground and sky.

Dry Into Wet

This approach is used by minglers who think they might become glazers. The usual sequence is to first apply a wet wash of color that will unify and enhance the second application of color. While the initial wash is still wet (some speed is necessary to achieve the best results), other colors are charged into the underpainting. The second charg-ing-in of color must be done with a rather dry brush loaded with pigment. The biggest problem people have with this approach is too much water in the brush when applying the "charging-in" colors. If the second application is done with too much water, the first wash is floated away resulting in *oozles*, a word coined by Eliot O'Hara mean-ing the homogenization of two colors into a nondescript gray.

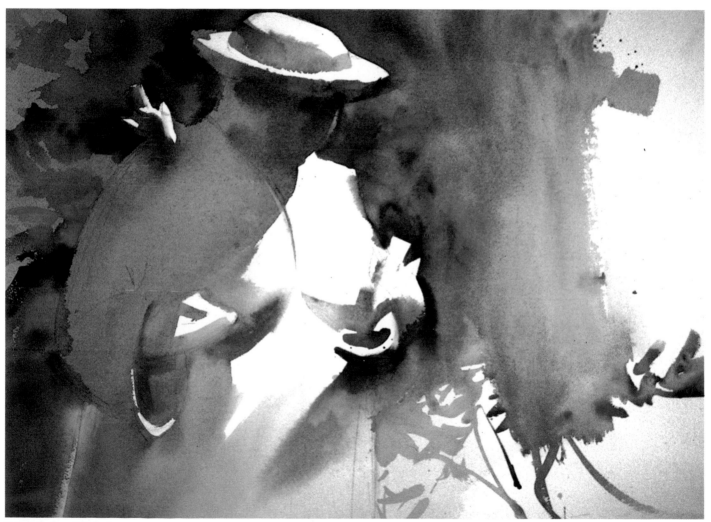

Bird Lady of Toledo
20" × 26"

An underpainting of red-violet defined the shape of figure and background. While this was still wet, I charged in thick amounts of cobalt blue, Indian yellow and Thalo yellow-green.

Wet Over Wet

I generally use the first wash to establish the value and temperature of the shape. I also use the complementary color as the underpainting. For example, if I want a warm violet shape, I begin with a warm yellow initial wash and rapidly glaze the violet color on top. The second color should be the same value as the first. This must be done with directness and confidence. Lingering too long will spoil the desired effect. Using complementary underpainting creates maximum luminosity. Any other color only serves to change the hue of the shape. Think about it: If I applied red to my initial wash of yellow the result would be orange; blue would make green; green would yield yellow-green, etc. There are times when it is my objective to make orange by charging red into yellow, but to create the greatest vibration of color I use complements.

Try this the next time you want to paint a warm sky: Cover the entire sky area with yellow ochre. Add a glistening wet glaze over the top portion with cadmium red. Adding the red will make the sky orange. Now blue, the same value as the orange (the result of mixing yellow and red), should be glazed over the orange area. Blue is selected as the complement of orange. The results will be a warm glowing sky that has enough blue to satisfy our need for reality, and a depth not possible with just the use of blue. Now what do you think of that?

With experience you will gain confidence and find yourself painting complementary colors under every wash. Experience will teach you the necessity of speed and the correct mixture of water and pigment. Your first attempt will probably be too dark, overworked, and done with twice the amount of water necessary—all lessons to apply to the second attempt!

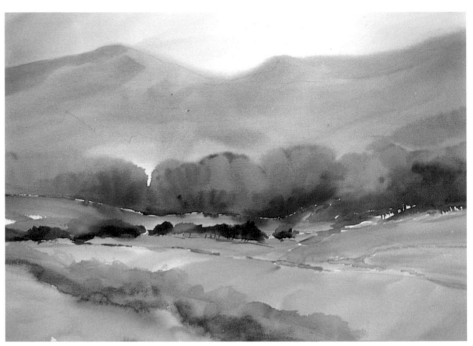

Greenville, NY
22" × 30"

This entire painting was done using complementary glazes of wet-into-wet. The sky and mountains began with yellow ochre followed by glazes, of the same value, of permanent red and ultramarine blue. Red was the base for the green trees and violet the base for the yellow-green foreground.

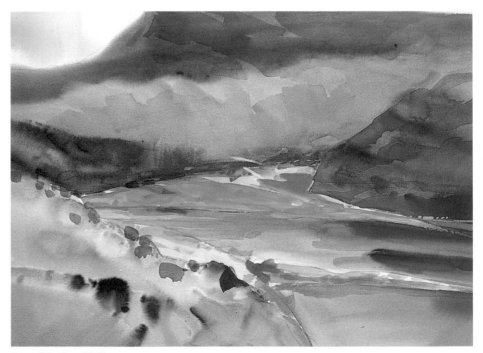

New Mexico Valley
20" × 26"

Under each of the colors seen in this piece is an underpainting of its complement. Each wash is applied while the initial wash is still wet.

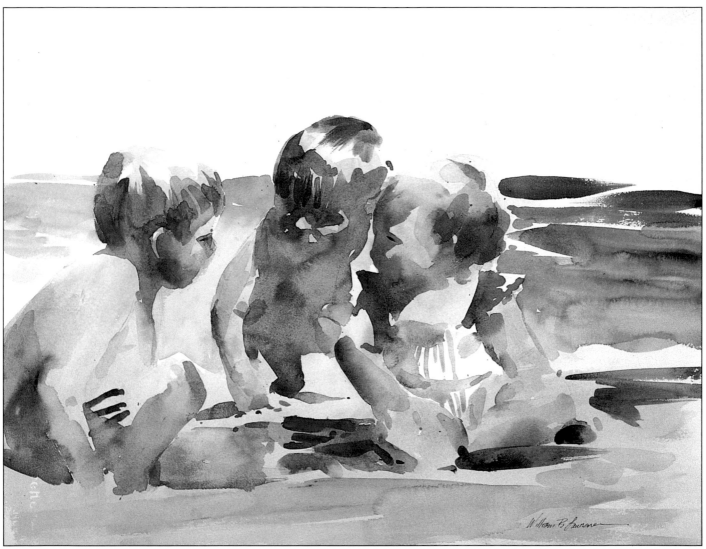

Wet Over Dry

Many watercolorists patiently build shapes by sequentially glazing wet wash upon dry wash. The only difference from the wet-into-wet technique is that each wash is allowed to dry before the next wash is applied. While this approach is too slow and calculated for my temperament, many artists produce outstanding works using a wet-over-dry technique.

Working with this approach requires a knowledge of pigment characteristics, whether it's transparent or opaque. Pigments fall into three general classifications: nonstaining transparent, staining transparent and opaque. For the best possible results, consider the effects of each group for the underpainting and glazing. Theoretically, opaque pigments cover an underpainting, staining transparent pigments dye an underpainting, and nonstaining transparent pigments allow the underpainting to shine through. There are times when each of these effects is appropriate.

Beach Talk
22" × 30"

The shape of the children was painted as a warm neutral color. After that was completely dry, sequential washes of warm and cool, darker values were applied to define shadow shapes. Notice the difference of pigment quality from the methods of wet-into-wet and dry-into-wet.

One Stroke

Somewhere in the history of watercolor instruction, there was a diabolical plot by someone to ensure that watercolor would be perceived as a minor medium. In a single statement, "Watercolor painting should be like your golf game, the fewer strokes the better," the plan was set in motion and thousands of victims became part of the conspiracy. Fortunately, enough painters knew that art, and not watercolor, was their goal and they have reversed the plot.

Unfortunately, there are still a few who adhere to this theory. When confronted with one of their efforts, I am reminded of a clothes hamper my family once had. It featured some single stroke roses as decoration. Watercolors done with the single stroke method evoke the same response from me as those roses—tacky, thin and cheap.

For the most part, this thin and cheap appearance is the result of water and white paper on pigments. Every color is qualified by the white paper showing through the transparent wash. White on any pigment reduces its intensity and lightens its value. Pigments applied in this fashion have the same look as the Sunday comics. I know of no good painter who uses the single stroke approach. Painting in watercolor is not a golf game!

Color Harmonies

Much of painting is about organization. Artists organize their thoughts and use elements toward a goal. The biggest failure of less-experienced painters in using color is a lack of organization. While almost any order or theory is preferable to none, there are many tried and proven color harmonies. Complementary, split complementary, analogous and triad are traditional color harmonies taught in every color course. While these traditional color harmonies are effective, they have limitations. The most obvious is that they limit the palette. I don't like limited palette painting or paintings.

Red Marcher
By Christopher Schink
22" × 30"

The three paintings seen here, done in a variety of styles, subject and point of view, have a common denominator—color harmony. Each is organized around the harmony of white, tint and hue. Unlike the more traditional color harmonies, such as triad and split complementary, using this broad-based approach to color harmony allows for a full spectrum of hues.

A more general approach to color harmony is useful and does not limit the palette. Pure pigments mixed with water become *tints* of color. These same pigments mixed with black (whether purchased or mixed) are *shades*. Add complements to these colors and they are called *tones* (neutral or near neutral tints). Unique to transparent watercolor is that white is achieved either by leaving paper unpainted or by using clear water.

Many of the paintings in this book are based or organized on one of these color harmonies: white, tints and pure hues; pure hues, shades and black; or tints, tones and shades.

The beauty of these broader-based color harmonies is that you have the freedom to use a complete palette of pigments.

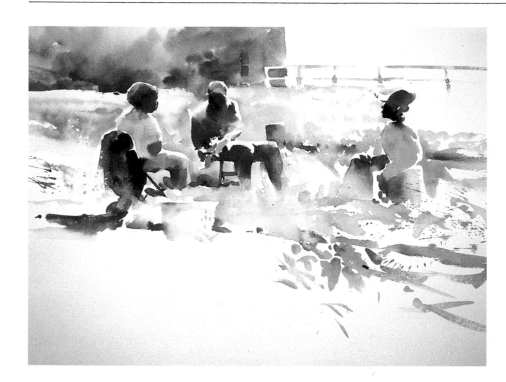

Lunch Break
20" × 26"

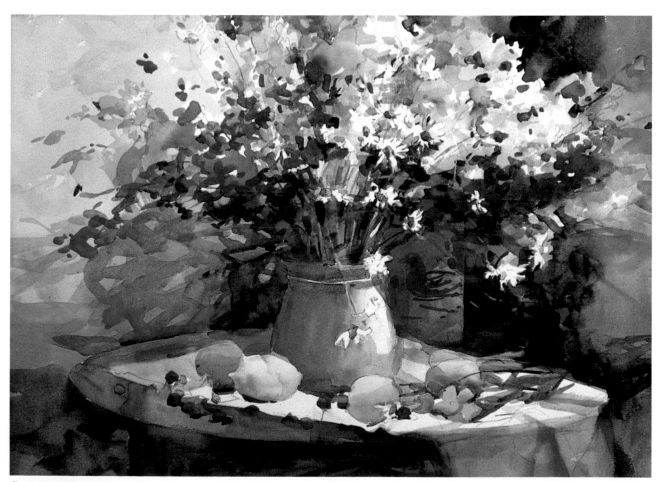

Summer Flowers
By Carolyn Anderson
22" × 30"

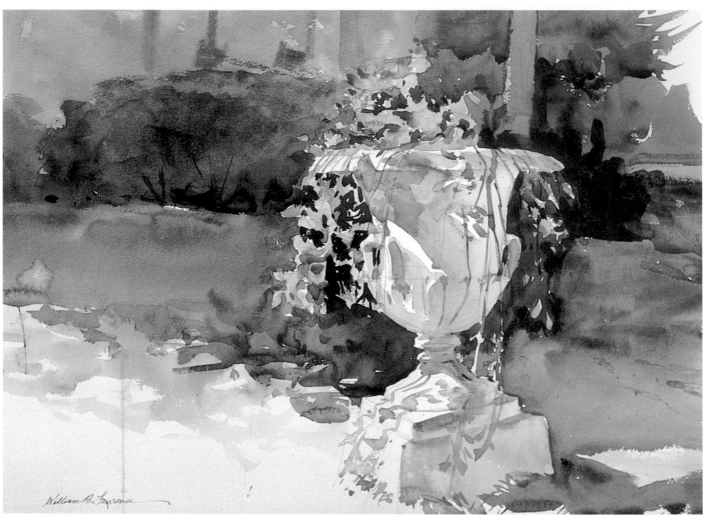

Greenville Urn
20″ × 26″

For the painting of this urn, which sits on the lawn of the Greenville Arms, I used a color harmony of tints, tones and shades.

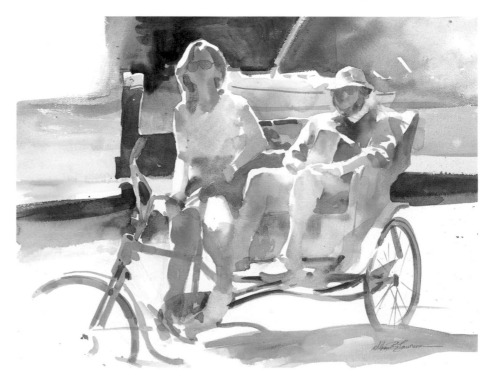

Annapolis Taxi
22″ × 30″

Complementary color harmony, used for this painting, is one of the traditional harmonies we all learned in basic art training. Others include triad, split complementary and analogous.

Out of Fruit
20" × 26"

Snow designs some great shapes. The patch of snow raked with morning light works well with a color harmony of tint, tone and shade.

Remember:

- To more accurately identify color, ask these questions: What is the value, what is the temperature, what is the intensity, and lastly, what is the color.

- Shapes are separated by:
 —value (light next to dark)
 —temperature (warm next to cool)
 —intensity (pure next to neutral)
 —hue next to hue

- Watercolorists fall into two groups when applying pigment: glazers and minglers. Glazers work in layers, applying wet washes over dry washes. Minglers charge or mingle new colors into wet washes.

- Color harmonies are no more than color organization. The broader the concept the greater the flexibility.

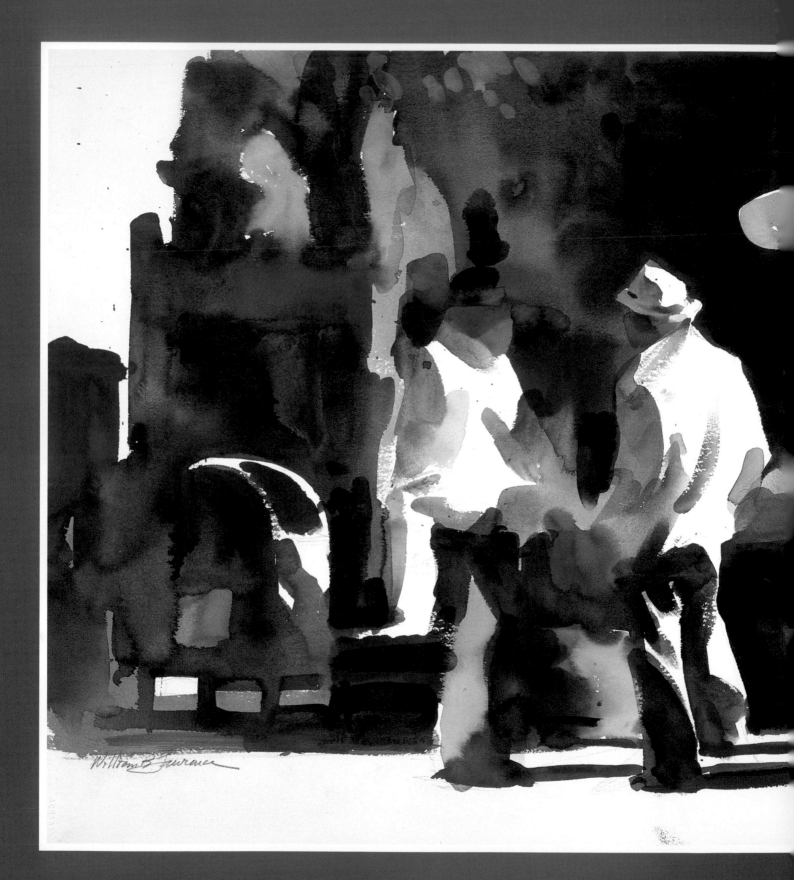

Chapter Seven

DEVELOPING CONTRAST

Determining Contrast Levels

It is essential to preface this chapter with some definitions. Value refers to the lightness or darkness of a shape somewhere on a scale between white and black. It is not the amount of money you can receive for a painting. Some use tone as a synonym for value. Color is self-explanatory. Pattern is the most nebulous term, because of its similarity to texture. For our purposes, when I refer to pattern I mean a collection of marks (generally small in size) that, when placed together, read as a shape. Another definition of pattern is surface variations. Texture refers to the actual tactile surface of objects, such as the difference between silk and a corncob.

After designing the best possible shapes for a painting and deciding on their relative sizes and positions in the painting, the next critical decision is how to make the shapes visibly clear to those who'll be looking at the painting. The word "reads" has been coined for this purpose. An instructor might say, "The shapes of this painting 'read' clearly." Shape clarity is the result of

contrast—contrast of value, pattern or color. It is important that you remember that these three elements function independently of one another. A shape created by value, such as a light shape surrounded by dark, reads regardless of its color or pattern. The same is true of shapes created using color or pattern. A red shape against a different-colored background is identifiable no matter the pattern or value contrasts. A busy, broken-up shape played against flat, quiet shapes maintains its identity no matter the value or color contrasts.

It is equally important, however, that you understand there is a visual pecking order to the contrast level of these three elements. For example, if you make a shape that has equal contrast of value, color and pattern, the contrast of value will be more visually aggressive than the contrasts of pattern and color. If you make a shape in which value contrasts are eliminated, and pattern and color are equal, you'll find that pattern is visually dominant over color. So the visual pecking order of contrast is value, pattern, then color. This should be important to you as a painter from both a technical and an

expressive point of view. For if it's your intent to make a painting with an emphasis on color, and you fail to reduce value and pattern contrast, you will produce a painting that is not about color at all. It will be a painting in which value and pattern have stolen the show, leaving color in a supporting role.

It is important that you determine which of these contrasts will dominate a painting. For if you don't decide, and do a painting in which there is equal contrast of color, value and pattern, the result will be a work in which each contrast neutralizes the others. Great painters understand this and that is why they are great painters. Andrew Wyeth is a value painter. His paintings have reduced color and pattern contrasts. John Marin's work emphasizes pattern and has minimal contrast of value and color. Vincent Van Gogh and Paul Gauguin were in love with color and realized contrast of pattern and value would challenge their objective. What are your paintings about? Are you a Wyeth, a Marin, or a Van Gogh? Not to decide is to decide!

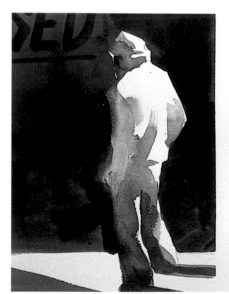

Value shapes

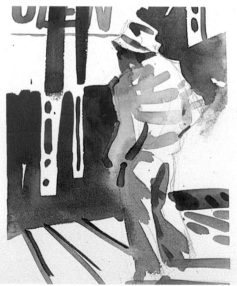

Pattern

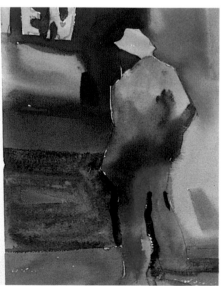

Color shapes

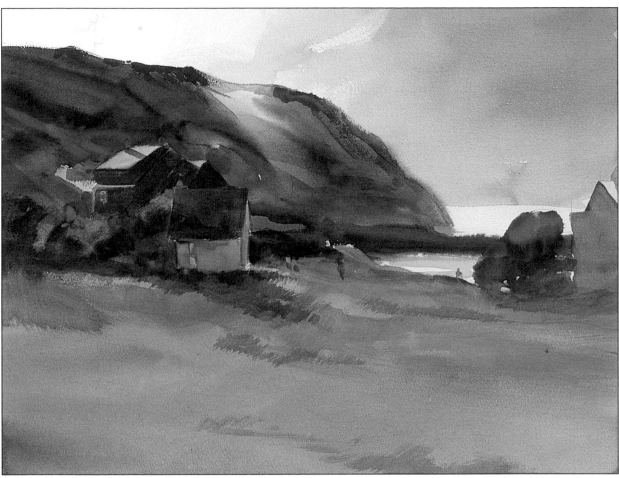

View of Monhegan 2
20" × 26"

Value

Value painters tend to be representational painters. Their concerns are how light and atmosphere affect the value and color of objects in space. The study of these observations is called aerial perspective. While aerial perspective is not a science, it comes close to science, because the results of light on objects and on the landscape are observable. These results do not call for interpretation or subjective reasoning. Objects that recede into the atmosphere appear lighter in value, cooler in temperature, and lose their texture definition. All you have to do is remember a few simple rules, apply them to some interesting shapes, and success is yours. In the hands of the best and most experienced painters, the results of values and aerial perspective can be magical.

The effect of light hitting an object is also an area where value reigns supreme. Place a strong light on a red ball and observe how unimportant the color becomes. The lighted side of the ball is now a bleached light pink while the shadow side reads as dark purple or black. The trick to modeling the ball is not in the use of color but in showing the value changes from light to dark and the important transition between the two. Paint the ball half light and half black, and the ball will not appear round. The illusion is in the careful gradation of values from the light side to the dark. Look at the paintings of Rembrandt and see how much care was taken to get from the highlight on the tip of the nose to the black background. These gradations are totally the result of value.

What the best value painters understand is that color only serves to confound the intent of the painting and that the less color the better. Study the paintings of Andrew Wyeth and other value painters and see if you don't agree.

Changing the value organization of the same scene reorganizes emphasis. It is a mistake to frantically search the world for ready-made compositions. It is better to explore the possibilities of one subject. In a seven-day visit to Monhegan, I painted this subject nine times.

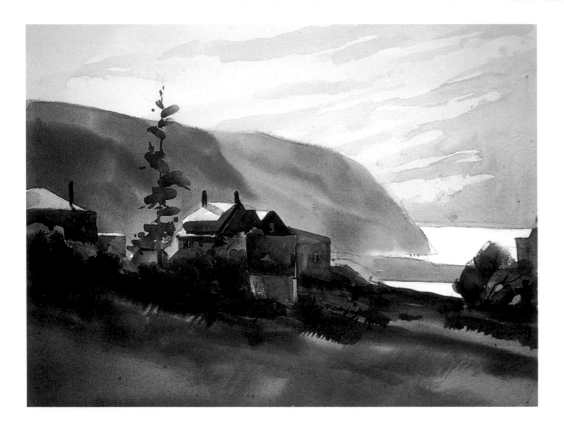

View of Manana
20" × 26"

A decision of whether to design in value, color or texture should be based on the expression desired. In this case, I felt the best way to describe the fading light was strong value contrast. There are several versions of this scene in the book. Notice how a change from value to color creates a totally different feeling.

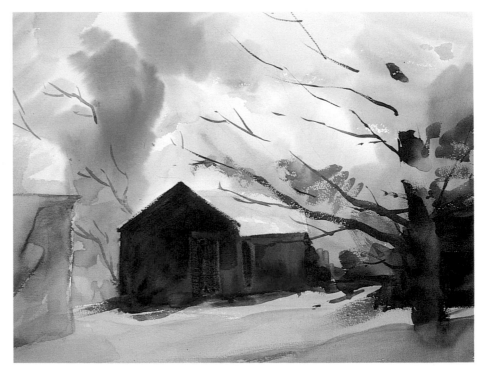

Greenville Fall
20" × 26"

In spite of the abundance of orange, this painting is designed with values. Values are visually more aggressive than colors. It was my intent to first express the quality of strong light on a fall day. Had it been my objective to celebrate the colors of the day, I would have reduced the value contrast.

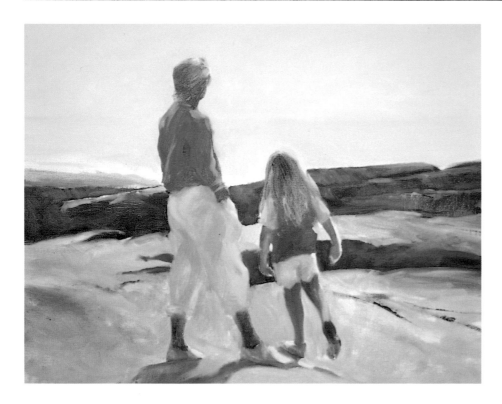

Shauna and Carly, Maine
Oil, 16″ × 20″

A painting of my wife and daughter at Acadia National Park is a simple pattern of light, middle and dark values. The gesture of the figures coupled with love was my inspiration.

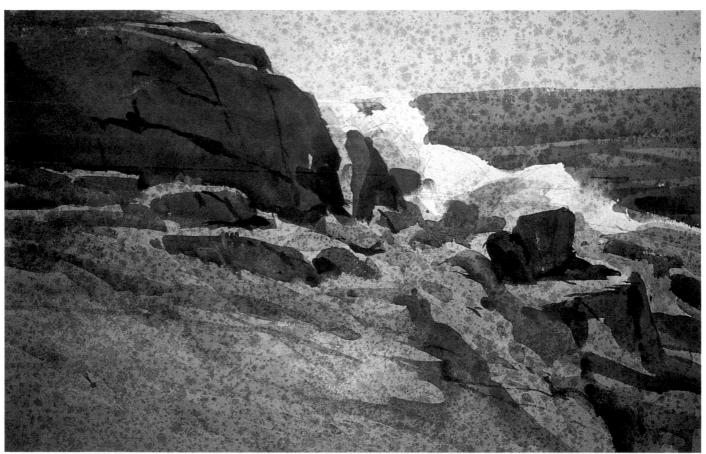

South End Monhegan
15½″ × 22″

The stark value contrast of the rocks to the surf dictated a value painting. While color plays an important role, this painting could have been done in black and white. Imperfections in the paper (original Whatman circa 1940) created the interesting texture.

Pattern and Texture

If your favorite painters include John Marin, Maurice Prendergast, Jasper Johns and Jackson Pollack, if you look at a subject and see lines, textures, and small pieces of color and value; if you are flamboyant and love excitement, it could be that you are a pattern painter and don't know it. Pattern painters have little concern for light and its effect on form or atmosphere. They love color, line, texture and movement, and use these elements to compose.

Pattern results when marks, lines and dots mass together in such a way that, when juxtaposed with contrasting masses, they read as shapes. The motivation for these marks may be based on the texture of objects (soft sky, rough bark), the directional thrust of things (trees pushing upward, boulders pushing down), the contour of surfaces (curved sweep of a wave, angular straight lines of rocks), or any other cue you observe.

While these are all inspired by observations, another reason to create pattern is the material itself. Van Gogh created his patterns of brush strokes, in part, because he loved the feel of the paint. Many followers of the California school of watercolor are rooted in an affection for brush marks. Their calligraphic marks dance across the page suggesting texture and pattern on every subject from landscape to figures. When done with restraint their work is exciting and captivating, though when carried to an extreme, it can become "a lot to say about nothing." I say this not to diminish the school, but only to warn that there are no shortcuts to success.

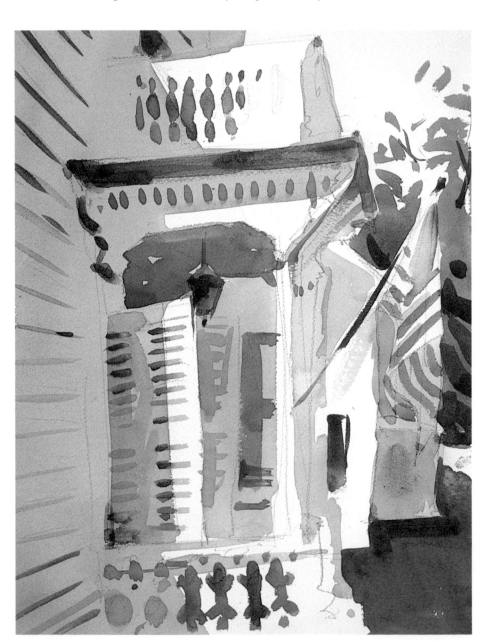

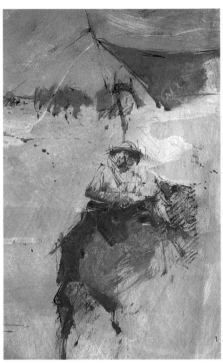

Cowboy
By Alex Powers
20" × 16"

Alex Powers finds texture captivating. His painting supplies include bristle brushes, knives and other implements. There is nothing soft about his equipment or images, save a genuine sensitivity to design, edges and statement.

Porch Flag
11" × 8"

This shows how stripes, railings, and foliage can be used to make texture and pattern.

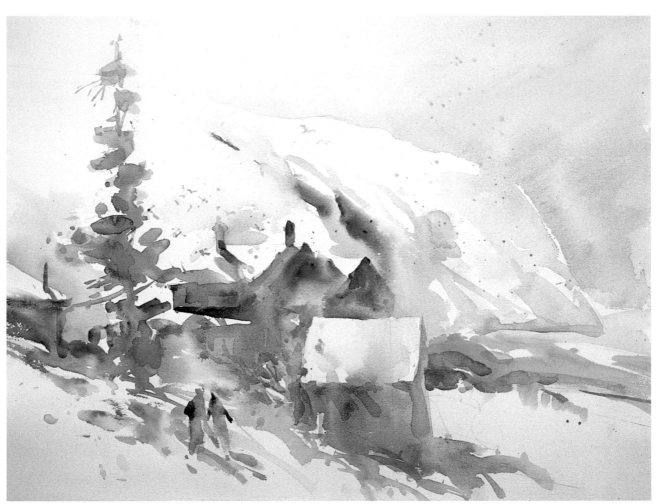

Monhegan Light
20″ × 26″

In my typical painting style this is as close as
I get to doing a texture painting.

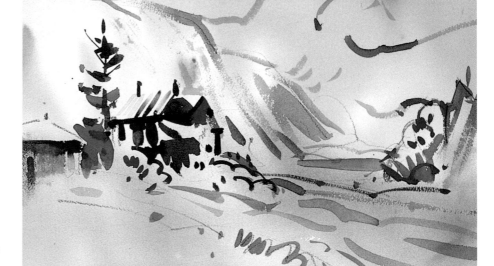

View of Monhegan
8″ × 11″

Contours, directions and textures combine to
show an alternative approach to the same
view of Monhegan.

Color

Remember that in our hierarchy of visual aggressiveness, color is weaker than value or pattern contrasts. If I prioritize these three elements on their ability to convey emotions, the order is quite different. Color now heads the list with value and pattern playing supporting roles. It's very simple. If beautiful color relationships are your goal, you must reduce the contrasts of value and pattern.

I believe thousands of painters in watercolor sincerely want to design in color, but unknowingly override the effects of color contrast by excessive use of value and pattern. Many of the paintings I critique would be improved by lightening all those last minute dark holes which are put in the painting to

To be a slave to realistic light is to deny your personality.

"give it some punch." They are a curse placed on watercolor students. These little dark accents are like pieces of spinach stuck between your date's teeth—they ruin everything!

It never fails, when discussing a student's painting, the first words spoken are, "I'm going to darken...." I wish just once in a while someone would say that's he going to warm, cool, brighten, lighten—anything but darken. It appears that everyone thinks value is the ultimate solution to any painting problem. So long as this attitude is held, color will be relegated to secondary importance. The next time the word "darken" crosses your mind while painting, try substituting "intensify" or "cool," and watch your painting improve.

Think about those artists we consider the best colorists and imagine their thoughts when making color decisions. Study the work of Monet, Bonnard, Turner, Cezanne, Van Gogh,

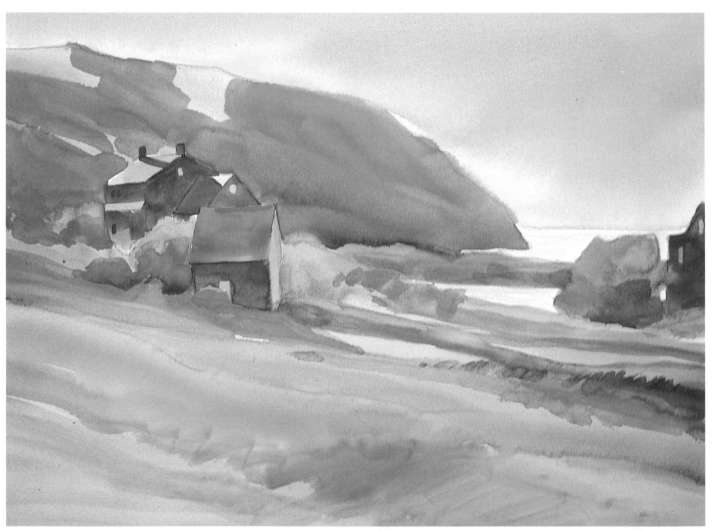

View From the Meadow
20″ × 26″

I have included many paintings of the same scene in this book to illustrate how ideas are more important than subject. This version is an expression of the joy I felt while painting from a porch at the Elfant cottage. The visual fact rarely covers the breadth of emotions and understandings we have for any subject.

Southwest Nuance
26" × 20"

All the shapes in this painting are made by changes of hue and hue intensity.
I often design with a color pattern rather than a value pattern. Colorists are
prone to eliminate extremes of value and concentrate on color. If you don't
consider the options, you are doomed to flounder in the middle.

Julian Weir, John Twachtman, Milton Avery, Richard Diebenkorn, Georgia O'Keeffe, and you will see artists who did not ask, "What value should this shape be?" But rather, "What hue, temperature or intensity should this shape be?" I intentionally did not include contemporary painters on my list for fear of omission, but let me assure you that, of the best painters in watercolor I know, the majority are colorists.

We have traveled far afield from the stated topic of this book, "designing with light," and you might be asking how this applies. The relationship is in our choices. For while light defines form in values, light and shade, light also defines color and texture. You can observe an object in light and decide to paint the value relationship. You

> **Light provides the clues to what is and might be. You have the choice of interpretation.**

can observe that same object in light and decide that rather than painting the lighted portion light in value, you'll paint that same portion as a pure color, such as orange. And the dark portion can be painted as blue rather than dark. Now instead of having a red ball described as light pink and dark purple, we have an orange and blue ball. The emphasis has changed from value to color.

We also have the choice of defining the shape as texture or pattern—the light side as rough and the shaded side as flat. These choices make all the difference. To be a slave to realistic light is to deny your personality. Light provides the clues to what is and might be. You have the choice of interpretation.

The Complaint
20" × 26"

Gulls offer an endless source of animated shapes. This shape is expressed as a cool neutral against warm tints. There are value changes, but they are kept close in contrast.

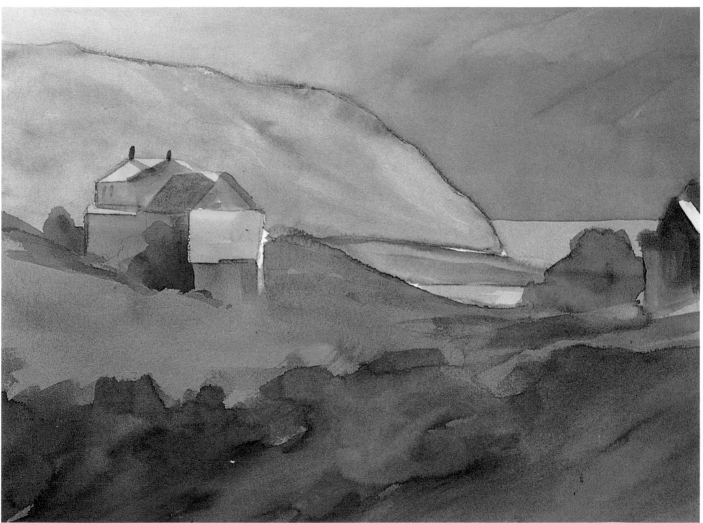

North End Manana
20" × 26"

To achieve the desired luminous light on Manana Island, color intensity contrast was necessary. I did, however, also have to lean a little more heavily on value contrast to create the glow. It should be understood that while a choice of color may be your objective, nothing is so sacred that you sacrifice the desired effect of the painting. Stay in dialog with the work in progress, and always be willing to do whatever is necessary to reach your ultimate goal.

Remember:

- All paintings are designed with shapes.
- Some painters make shapes with value.
- Some make shapes with color.
- Others make shapes with texture or pattern.
- All approaches will work if you declare which you are using.

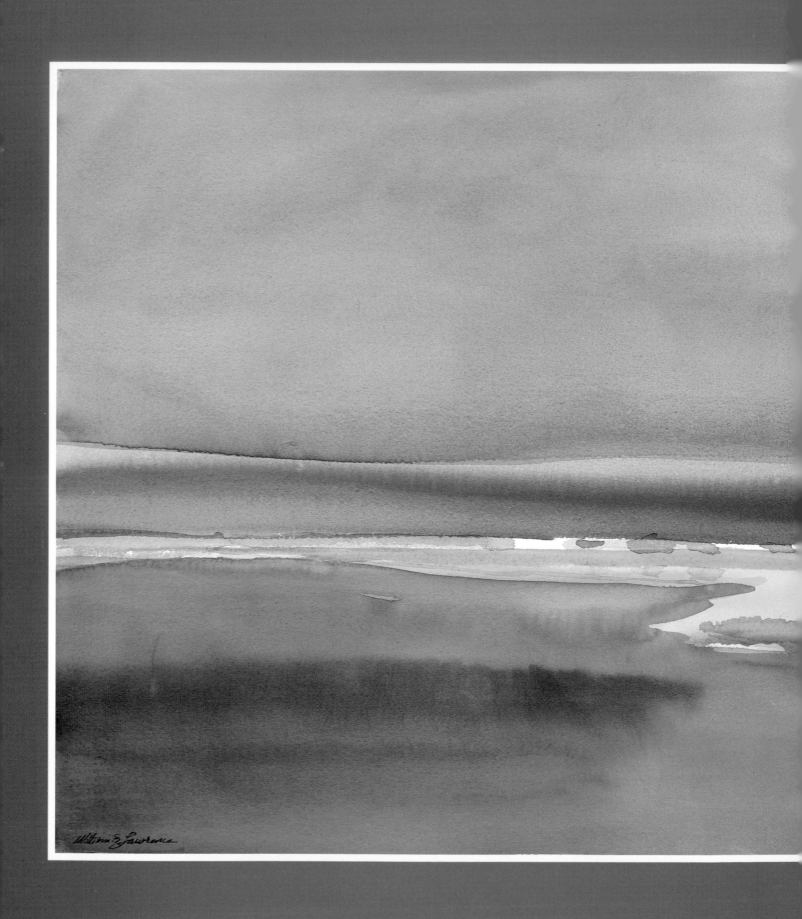

Chapter Eight

CREATING MOODS

Expressing the Color of Light

Light comes in a full spectrum of hues. Just west of my home in Mt. Airy, Maryland, are the Blue Ridge Mountains. The mountains of Albuquerque are called Sandia, which means watermelon, because of their bright red color. "Purple mountains' majesty," a line from *America the Beautiful* refers to the color of distant mountains. I have seen all these places and know that none of them are blue, purple or red. It reminds me of the first grader who was told by his teacher not to leave a space between the sky and the grass, because they actually do touch. The boy responded, "I've been there and they don't."

The effect of light and atmosphere creates the colors of blue, purple and

Remember that local color is just one truth about a subject — the visual truth.

red. The Blue Ridge Moutains are the result of our looking through veils of blue atmosphere illuminated by clear white light. Purple mountains only appear when backlit by warm yellow atmosphere. The mountains of Albuquerque appear red only when an orange sunset reflects off the pink face of Sandia. What we actually see is the color of light.

An awareness of and sensitivity to the color of light, be it natural or artificial, adds greatly to your expressive vocabulary. Don't allow your brain to dictate to your eyes what they are seeing. By identifying the ambient light, you are armed with two terrific tools that will improve your painting. First, you can create moods. The white light of summer, pink sunsets, green moonlight

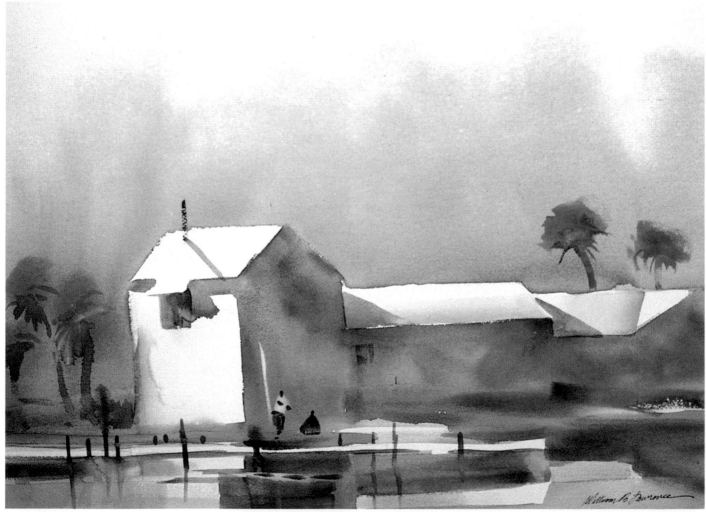

Florida Orange
20" × 26"

Obviously the colors I saw when painting in Crystal River, Florida, were not this orange. Just as obvious is that Florida is warm and that it's famous for oranges. By running sequential washes of Winsor yellow, new gamboge and permanent rose I established a color dominance, a warm mood, and an expression of essence. A few touches of blue-green exaggerate the orange and, by temperature contrast, complement the warm.

scenes, yellow-green spring days, red-violet rains, yellow-orange fogs are all created with the color of light. Some of my favorite landscape paintings are not those done on clear sunny days, when local color dominates, but those done on inclement days when the atmosphere turns a decided hue, and local color yields to that hue. I like the paintings of English painter Trevor Chamberland, who does a lot of painting in inclement weather. I'm certain that much of his decision to paint in fog and rain is dictated by the climate of England. The second advantage to painting in fog, rain, sleet, snow and thunderstorms is the color of light—light that provides a dominant color unifying every area of the landscape into a cohesive oneness. The next time it rains, instead of postponing your on-location painting, pack up your stuff and take advantage of the opportunity.

To this point we have been talking about "cause and effect." Moods are dictated by Mother Nature. But you are not obligated to wait for a thunderstorm to create a mood in your painting. As the artist, you can create any mood you want at any time you want. If it suits your purpose to paint the world orange for any reason—just do it! Remember that local color is just one truth about a subject—the visual truth. Think about how you truly feel about the subject or the truth of how the subject physically feels. Include all your senses, understandings and emotions when deciding on the mood or dominances of the painting.

Near Mountaindale
22″ × 30″

The sky is done wet-over-wet with yellow ochre, permanent red and cobalt blue. The triad of primary colors, in mixture, gives an overall effect of neutrals. These same pigments are used on the wet road. The land is painted in complementary glazes which will be seen as dark and neutral.

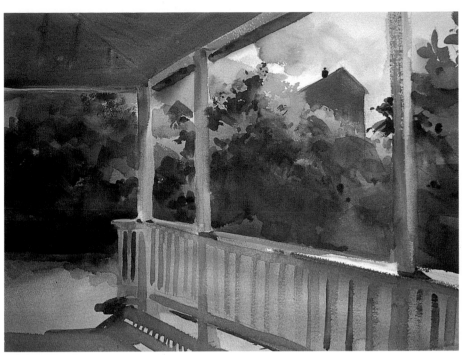

The Elfant Cottage
20″ × 26″

Local color, perceived color and actual color are all terms we use to describe the color we see. Nature's colors are generally muted. Fire-engine reds, white and black are rarely colors we see in nature. Consequently, representational painters tend to paint in tones (values of neutral colors). Even when bright hues are offered, they're not applied in pure form. Painted from the porch of our summer cottage on Monhegan, this painting shows the neutral tones of nature with even the roses' red color played down.

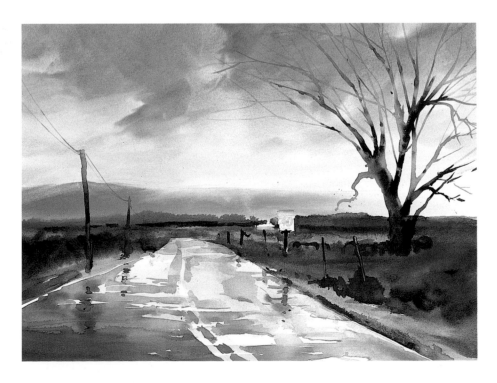

The Actual Color

The ability to identify actual color is not as simple as it sounds. The ability to correctly identify color is to first cleanse the mind of any preconceived notions as to what color we have been conditioned to see. Skies, for example, are rarely blue. Secondly, we must identify color in relationship to surrounding colors. A red ball on a green floor is a very different color from the same ball on a yellow floor Thirdly, we must be specific about color's subtle changes of value and intensity. Lastly, we must remember that the three-dimensional world, from which we are gathering our color clues, is filled with reflection. Every color we see is reflecting onto every other color. It is this reflection of color that makes even opposite colors harmonious. The flat surface on which we paint cannot reflect a color onto its neighbor. Therefore, it is our job to make the color changes necessary to achieve the same effect.

The truth of the matter is that local or actual color is of little value other than as a beginning point. The best paintings are not those that match local color to record the truth, but those that exaggerate color to express a truth. Be sensitive to color. Look at the scene, the room, the figure, and identify the ambient color, temperature and intensity. Then use that information expressively and compositionally. The color of the ambient light affects the color of everything it touches. If the sky is blue, there should be evidence of blue on every plane upon which the blue light falls.

Moors of Monhegan
15½" × 22"

There was little need to alter the actual colors of this scene. The warm neutral yellow-green of the middle ground was set off by the cool neutral colors of the rocks, distant trees and sky.

Schooner
By Don Stone
Oil on canvas
10" × 14"

My good friend Don Stone of Monhegan Island, Maine has a rare ability to observe nature's subtleties. This painting is flooded with light, yet the color hasn't been lost. Notice the warm rose color that seems to be evident in the blue water, gray rocks and white schooner.

Alfred's Fish House
20" × 26"

Expressive Color

There seems to be a belief that if a painter matches each color exactly as seen, reality will be the result. Nothing could be farther from the truth. You need only look at the photos from your vacation to know that they don't reflect the feelings you had when looking at the real scene. Our impressions of a place are the result of many realities, the visual reality being only one. How you feel about a place might be in direct conflict with its appearance. I have been to brightly colored places that I hated; the reptile trailer at the county fair comes to mind. Blue skies, blue-green water, green foliage (all from the cool side of the color wheel) are not very expressive of the warmth of a tropical island. On the other hand, I have been extremely excited by a foggy day in Maine and know that

I remember doing this painting of the fish house, which has been painted a thousand times, and thinking all I wanted to achieve was the subtle quality of light. The houses, harbor and Manana Island were only objects that lived in the light and provided an opportunity to paint the light.

Payne's gray won't convey my feelings of joy. On the other hand, one should not allow enthusiasm for a place to negate the very essence of the subject.

The best paintings are not those that match local color to record the truth, but those that exaggerate color to express a truth.

I remember my first critique at my first workshop with Edgar Whitney being, "Bring this kid all the way to Maine,

take him to a worm-ridden, dirty old boat yard, and he paints a damned Mardi Gras." The problem was that my painting was not in response to the boat yard, but rather an expression of enthusiasm for the situation.

My advice is to take time to look beyond the visual facts and find the colors that express your feelings. At times the local colors are appropriate for the subject, and at times they are totally inappropriate. You need only look at the work of great painters to realize that many of their color choices are not factual, but expressive.

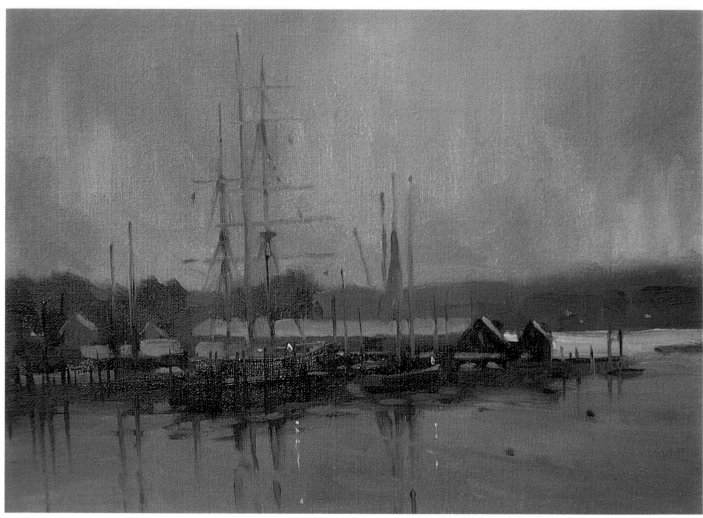

Rocky Neck
By Don Stone
Oil on canvas
8″ × 10″

If you can see the value and color of light, that which exists in the light is of secondary importance. Don Stone is a master of painting light. His comment to me when I spoke to him about designing with light was, "How else can you paint?"

Morning Reflection
12″ × 16″

I should have titled this work "water." The air and the pool were filled with water. The only color which emerged was the orange color of the bank. To express the wetness, I imagined myself painting underwater. This thinking allowed me to lose most edges, forget details and keep values close. Contrasting these elements with the orange created the desired mood.

Pemaquid Cottage
20" × 26"

Rhododendron by our summer cottage inspired this painting. The sunlight and the flowers were expressed as light in value and pure in color. All other shapes or objects were seen as neutral warms.

"What If" Colors

An approach to color selection that I find informative and exciting is the "what if" approach. Here you look at the local color of a shape, such as the sky, and say "what if" I paint that blue sky yellow. Now, it's not enough to just say it, you have to do it. After having painted the sky yellow you have set in motion an entirely new direction for that painting. First, you have escaped the rigidity of the factual color. Secondly, all subsequent color decisions must be related to the initial color. You are either making intuitive or cognitive color choices, both of which involve you personally in the painting process. Having freed yourself from the fact, there are no limits to possibilities. You may discover that you are a latent abstract expressionist who has been dying to be set free. Why, you may find that green roses against a red background are not only more exciting, but even more expressive of how you feel about roses than you imagined. People will look at your work and praise your creativity or perhaps suggest you are crazy. In either case you will know the satisfaction of receiving genuine response.

At the very least you will know the joy of making color choices that come from your heart and mind rather than your eyes.

Recently I was doing a demonstration painting of two mules for a workshop. The lesson was on the color harmony of white, tint and hue. Using the shape of the sunlit backs of the mules as the white, I began to paint the shadowed portion of the mules in pure colors of blues, blue-greens, violets and orange. There were gasps and groans of excitement from the audience. While it was not my intention to shock, it was gratifying to hear the excitement, for I felt that I had opened a door of possibilities for some. As a teacher, this is far more rewarding a response than the admiration I would gather from a straight rendering.

Your willingness to experiment with color will yield many surprising results, the most rewarding of which is when selecting the opposite of the actual color turns out to be exactly what you want to say. I don't understand this phenomena, but I am amazed at how often this approach yields the best results.

Another benefit of "what if" color choices is the satisfaction you get from being creative. One thing is for certain, as long as you continue to paint only in local colors, there is never a chance of discovery. I think it comes under the category of "no guts, no glory." I will never forget the declaration of one student, "I absolutely refuse to be intimidated by a damned piece of paper."

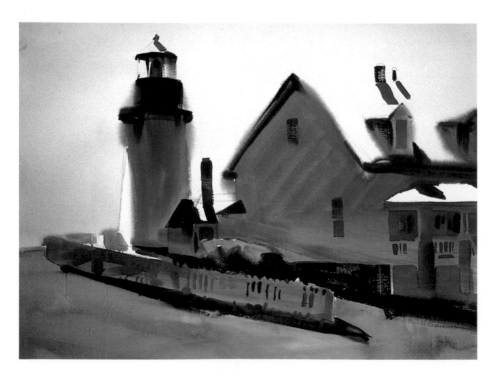

Pemaquid Point Lighthouse
20" × 26"

It is said that familiarity breeds contempt. Familiarity also breeds exploration. I have painted this lighthouse so many times that exploration is in order. A "what if" approach to color is exciting and revealing. Quite often these experimental colors are more accurate expressions of some intrinsic qualities than the local color is.

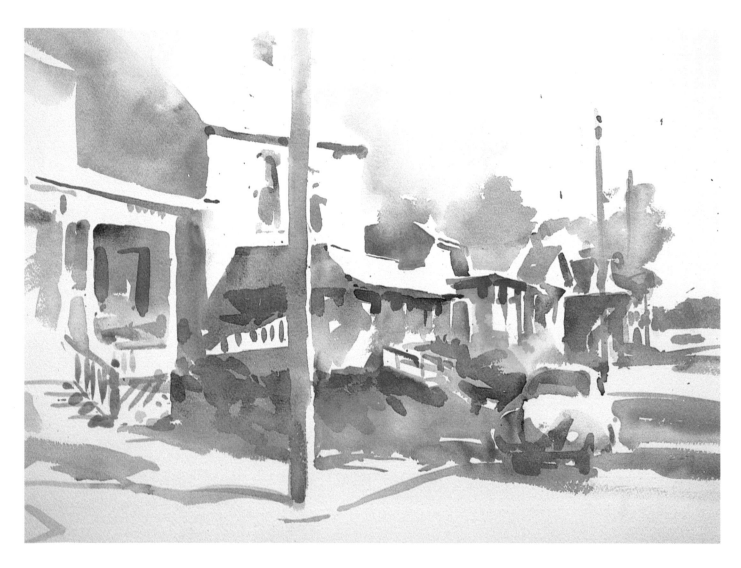

Back Street Beaufort
20" × 26"

When painting the shape of shade I rely on years of experience and take an intuitive approach to color selection. I start with a color and alternate warm to cool, pure to neutral, and make hue changes at impulse.

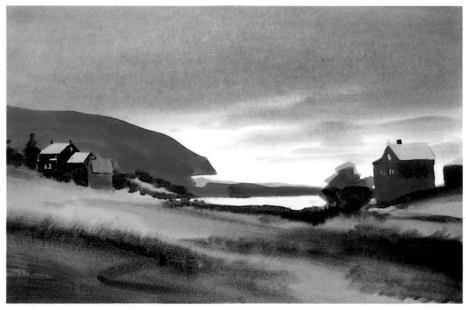

Sunset Monhegan
20" × 26"

Pure ultramarine blue, cobalt blue and Winsor green expressed the darkness of the sky. I remember thinking, what if I paint these shapes with pure color? I think they work.

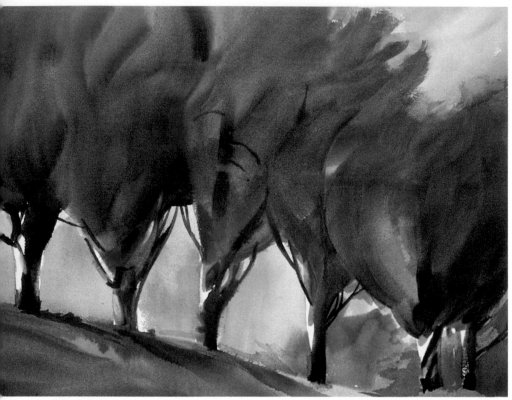

Tree Line
22" × 30"

Painting is organizing your thoughts. My initial thoughts were to organize this composition with values, dark and middle against light values. With this as my approach I was free to explore color. Sunlight was expressed as pure warm colors. The tree shapes, which correspond to the shade shape, were done with pure cool hues.

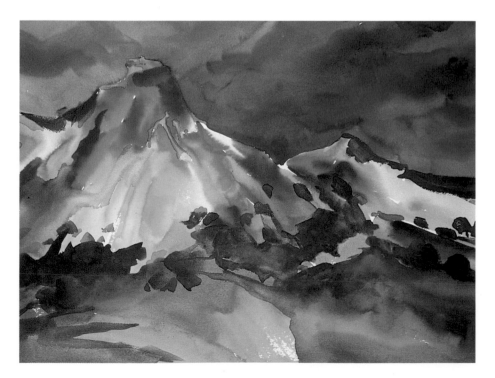

Outrageous Color

How many of you like the paintings of Vincent Van Gogh? I am imagining the number to be a very high percentage. During his life the number was very small. What has changed? Certainly not his paintings. What was thought to be outrageous one hundred years ago is now considered ultimate beauty. This can only be the result of changed taste. Our changing tastes are the result of education, familiarity and conditioning.

What has this to do with designing with light or creating moods? Nothing! It is just my way of encouraging you to free yourself from erroneous concepts of what painting should be. The choices are clear. Either you follow the traditions of an evolving art or you break tradition and explore the possibilities. I am not talking about change for the sake of change. I am talking about your willingness to listen to your inner voice and make art that is an honest expression of what you think, feel and know. It is not so much a case of seeking new approaches to art, as much as a willingness to let go of the old. If it feels right to paint the shadowed shape of a figure's face green, do it! Who knows, one hundred years from now your paintings may be the standard of beauty.

Watermelon Mountain
20" × 26"

The Sandia Mountains of Albuquerque, New Mexico, gave me a chance to exaggerate the red melon colors of its name. As unnatural as this may appear to those who have not been there, I have seen the mountains look just like this. Any cue is reason to explore an idea. Take every opportunity to act on an impulse—you'll never know what is possible if you don't.

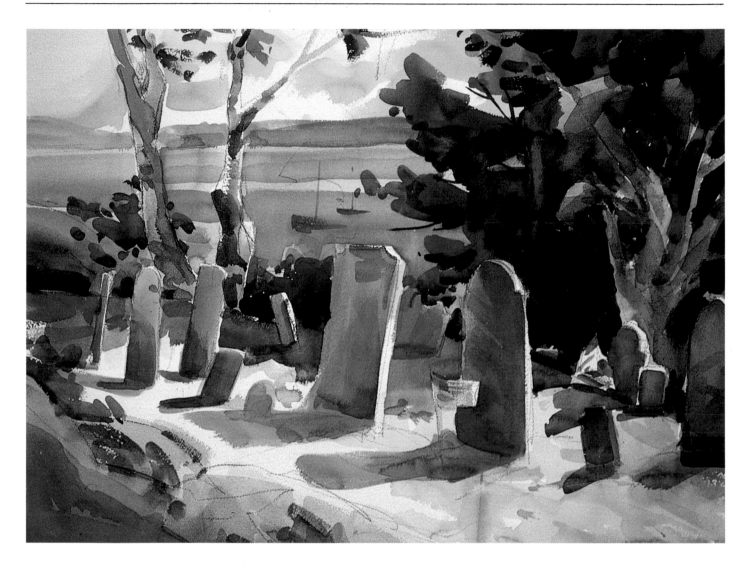

Remember:

- Actual color and local color are really perceived color.

- Actual colors are continually altered by the color of light and reflected color.

- It is impossible to portray true color without an awareness of the effects of light on local color.

- Expressive color is subjective and selected by the heart and mind, not the eyes.

- "What if" colors are intuitive and speculative and often revealing.

- Outrageous colors are extreme exaggeration and often contradictory.

A Marble Orchard
20" × 26"

This was a demonstration of the color harmony of white, tint and hue. The resulting work was an outrageous color scheme, considering the subject matter. When I finished a student said, "Now there's a graveyard to die for."

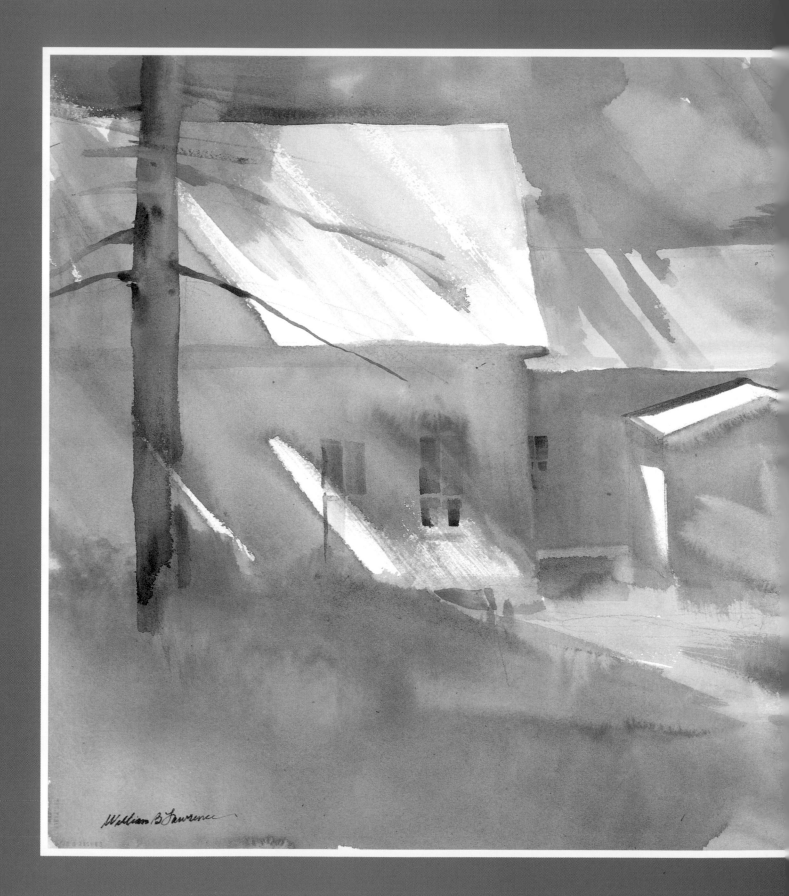

William B Lawrence

ACHIEVING UNITY IN YOUR PAINTINGS

Think Big

It is difficult to get a group of artists to agree on anything. The realist points to the abstractionist and says, "A monkey could do that." The abstractionist declares that realists are human cameras whose work is emotionless and little more than craft. The conceptualist feels that both groups are too concerned with media and that real art is about ideas and nothing else. Art is like religion: While all members of a particular religion profess a belief in one god, each denomination is certain that only it knows the true meaning of how to worship that god.

There is, however, one concept on which most artists agree, and that is the need for *unity*. Unity is relating elements into a cohesive partnership all aimed at a single goal.

Unity is ruined when one element loses sight of the goal. In ballet it's a ballerina tap-dancing in the middle of the *Nutcracker*. In music it's the piccolo player who decides to try interpretive jazz while the symphony plays Bach. Imagine the statue of David, done by Michelangelo, with a head by Rodin. In each case unity is lost, either because of a change in style or the failure to keep a common goal in mind.

I have given some rather extreme examples of how to kill unity. We are all guilty of compromising the unity of our paintings, generally for the reasons

Begin with big ideas and follow through with big shapes, big colors, big patterns and big expectations.

just stated. The best approach to maintaining unity is to think *big*. Begin with big ideas and follow through with big

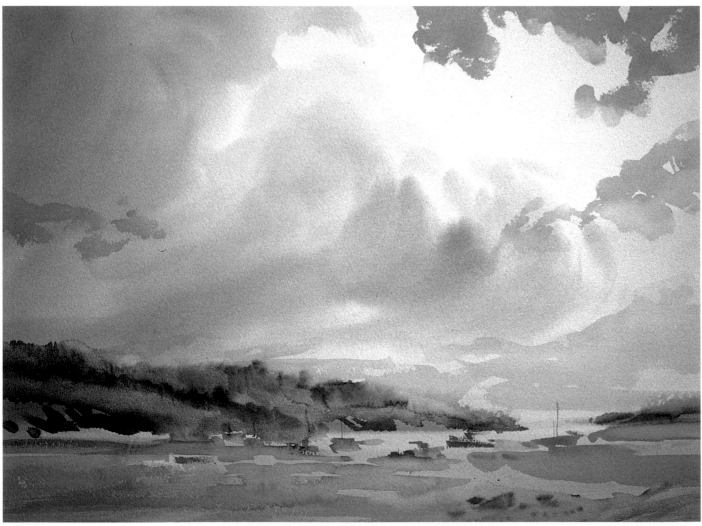

Big Sky
20″ × 26″

Nothing is as big as the sky. This beauty happened one July at Pemaquid Harbor, Maine. The most difficult aspect of making this shape effective was keeping the value light yet still showing the form of the clouds and the excitement of the moment. It is important to establish a large shape with a dominance of value and color. Having done so, the color dominance of the entire painting is made.

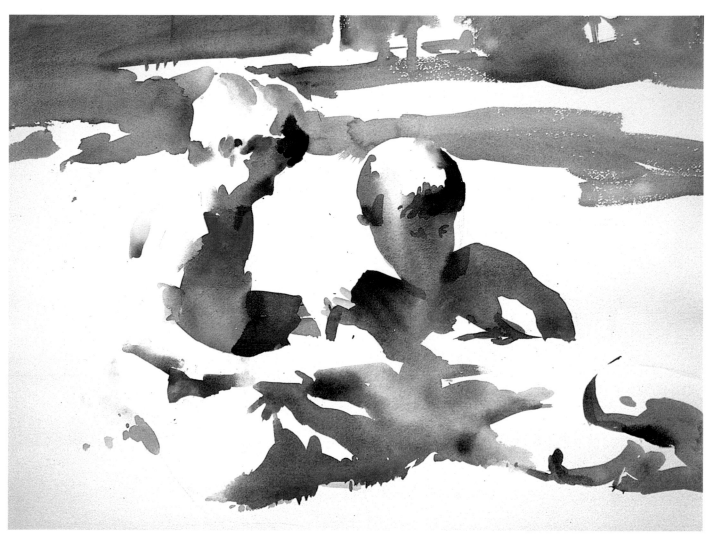

Lawn Talk
20" × 26"

shapes, big colors, big patterns and big expectations. The word that is most helpful in achieving this goal is dominance. Dominance is the principle of design that creates unity. If the ballet has dominance of movement, the symphony has dominance of sound, and the sculpture has dominance of style, and all parts are harmonious, then unity is evident.

You should first begin with the idea of big shapes. You cannot look at a sky and see ten clouds with seven sky holes. You must see the sky as one big shape dominated by a value and color. The same is true of the land. If you can see the land not as twenty trees and five houses, but as one shape that is dominantly of one value and color, then you are thinking and seeing

big. To maintain the bigness of a shape you cannot make extreme changes of value or color that subdivide the shape into smaller parts. Keep the values close and the shape holds together as a single shape (dominance of value). By keeping the colors close, the same virtue results (dominance of color).

If you think back to chapter one, "Seeing Shapes, Not Things," we were dividing the subject into two shapes— light and shade. The result of this approach was to take numerous small shapes and combine them into big shapes. It is my sincere hope that you are now both willing and able to design your paintings with big simple shapes. The rest of this chapter deals with how to make these shapes visually exciting.

The shapes of this piece read like two boys. It was painted as a network of inter-connected segments created by light and shade. Just as a piece of music pulsates with crescendo and decrescendo, so does this shape. Changing intensities and hues accentuate important spots and quiet others. This is my approach to making large shapes visually exciting—change colors, not values.

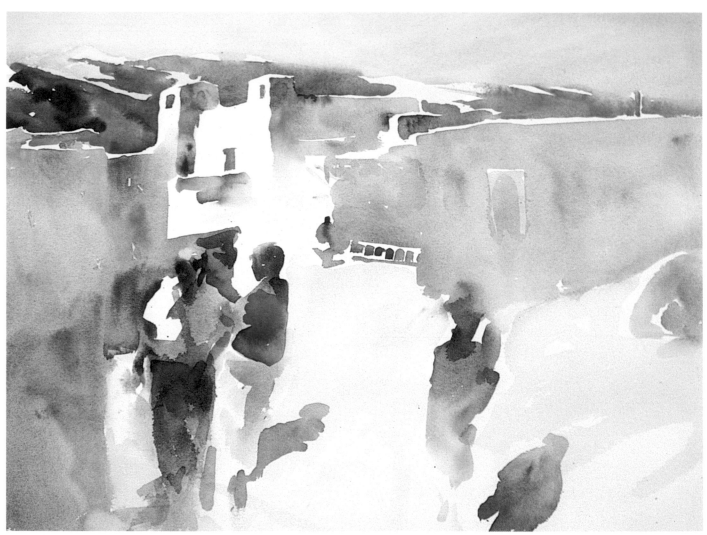

New Mexico Village
20″ × 26″

Changing Color, Not Value

To have a shape that maintains its identity and is also visually exciting, you should keep the values close within the shape and make numerous color changes. The logic is that as the contrast of one element is reduced, you become free to exaggerate the contrast of another element. It's true. Take a sheet of watercolor paper and paint every inch of it with as many varieties of red as you can—light red, dark red, intense red, neutral red, every manufacturer's red. Does the page have dominance and visual excitement? Now take another sheet of paper and paint it all value three (very light), but make as many color changes as you possibly

can. Does the page have dominance and visual excitement? This exercise can provide you with a wealth of insight into your painting, for it is probably a microview of how you paint everything.

From the total composition to the smallest detail there is a delicate balance of unity and variety. In the exer-

Perhaps the greatest paintings are those that create a perfect balance of unity and variety.

cises just described, I asked you to ensure unity by limiting the variety of elements (value in one and color in the other). At the same time I asked that you ensure visual excitement by maximizing the opposite element. Where

By painting the entire village in warm neutral colors of the same value, color dominance is achieved. With this big shape and color dominance in place, the value and color contrasts of the figures and mountains become the contrasting focal points of the painting. When all the shapes of a painting are the same size with ever-changing hues and values, the painting is about everything, and therefore it is about nothing.

value contrasts were kept close, we made unlimited color changes. Where color contrasts were limited, value changes were unlimited. Perhaps the greatest paintings are those that create a perfect balance of unity and variety. Most of us come down on one side of this balance more often than the other. People who limit their palette to three colors are ensuring unity through dominance of color, but they rarely achieve a spectacular color presentation. Those who throw everything imaginable at the paper without concern for unity, create chaos.

Let's begin by handling one shape and later address how to apply these ideas to the total composition. First, there is the shape—a shape that has been created with concern for aesthetics, visual interest, placement, size and clarity of statement. Certainly a shape that is the expression of such profound and genuine thought should not be destroyed through careless handling. One approach to saving the identity of this shape is to decide on a value range (light, middle or dark value). You may want to be as specific as deciding on value six. Having selected a common denominator of value, you are free to explore an infinite number of color changes. Believe me, it is quite impossible to exaggerate color changes so long as the value changes are very close. You can actually make a game of changing colors within a value shape. I have tried many things: alternating warm to cool; making every color change the exact value as all others; adding one hue to every other hue used in a shape; or making a shape appear warm while using a dominance of cool hues. The subject certainly has to be considered when making these color game decisions, but don't hesitate to explore possibilities.

Sandia View
20" × 26"

This painting is divided into three shapes. Value changes within each shape are held to a minimum. Value changes between shapes contrast. This is a simple but effective approach to making shapes read clearly. With changes of color you can create differing atmospheric conditions, changing moods and light, while working with shapes of the same value.

Boathouse Interior
20" × 26"

Whenever it becomes necessary to keep values close, as in an interior, you are left with color or texture contrasts within that shape to create exciting visual changes. Notice the color changes used in this interior shape. The right side is red-violet, the ceiling is yellow and orange, the left side blue-violet, and the bottom more blue.

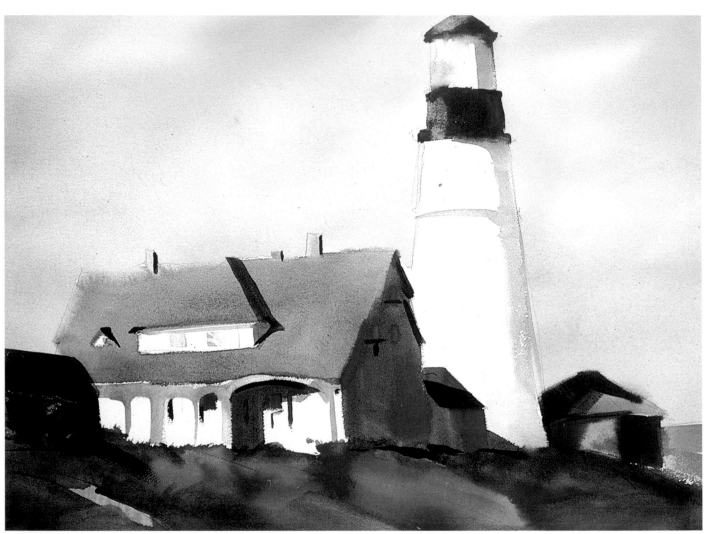

Portland Head Light
20" × 26"

Changing Value, Not Color

Limit the color range and you can go wild with value changes. As a matter of fact, if you limit the color, you better go wild with value contrast. Think about the artists who limit the colors in their work. Are they not the same people who exaggerate value contrasts in their paintings, working from white to black? It's really quite simple: As you exaggerate the contrasts within one element, you must reduce the contrasts within another.

There are many ways to limit the color range of a shape. You may decide on one color, say blue, or a limited range of colors (blue, blue-green and blue-violet). It is an easy jump from these blues to limiting your colors to just cools. This allows you to add greens and violets and an occasional touch of red-violet or yellow-green. You may decide on a mixture of colors that allows you to make a wide range of value changes and subtle changes of warm to cool temperatures while still limiting the color range. Yellow ochre, burnt sienna and ultramarine blue form a triad that fits this bill, as does any triad of color complements.

Dominant shapes are not necessarily the largest shapes. In spite of the strength of the lighthouse symbol and the size of the sky, they cannot dominate the power of the orange foreground. This painting is divided into two value shapes. The sky, front of house and tower make up the light shape. Land, buildings and the top of the tower are the dark shape. Simplify the value shapes and change color.

Sandia View 2
20″ × 26″

In the earlier version of the same scene, I changed colors within a close value shape. In this approach, I changed value within a color shape. The sky is dominantly orange, the mountains green and the foreground blue. If a shape is held together by color, then value and texture are available for contrast changes.

After the Storm
By Charles Sharpe
15″ × 22″
Collection of the artist

This is a prime example of working with a limited palette and changing values. Unity is achieved through a color dominance of orange. By extending the value range from light to dark, Sharpe expressed the drama of the subject.

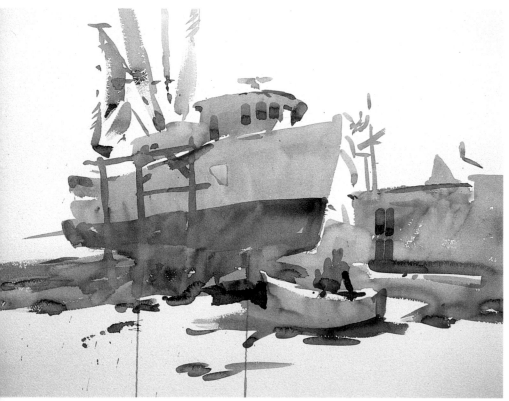

Beauford Boat Yard
20″ × 26″

The big shape here is the light value near the neutral hues pattern of the boats, land, water and buildings. The contrast is small bits of pure color that sparkle in their surroundings.

Beauford Flats
20″ × 26″

My thinking was to use neutralized hues to make the big shape and concept of this painting. The water, sky, foreground land, distant trees and middle ground are neutral intensities of local color. The light-struck sides of the buildings, coupled with the pure intensities of the land closest to the houses, are the contrasting focal point.

Intensity Shapes

Color dominance can be achieved by limiting the intensity contrast range within a shape. At one end of the intensity spectrum are the most intense colors possible. Select the most brilliant pigments on your palette and use them full strength. Like most extremes, the results of this exercise have limited audience appeal. One level down from this approach you slightly reduce the intensity of all pigments. Continue with this sequence and you eventually get mixtures of complements that are absolutely neutral gray. All along this scale are color intensity ranges suited to exactly what you want to say about specific subjects. I strongly suggest you explore the intensity scale, just as you have studied the value scale, and make it part of your painting vocabulary.

One approach to mixing neutral and near neutrals is to mix a pool of primaries (red, blue and yellow) until all color identification is impossible. By that I mean a gray color that does not look yellow, blue or red. Having achieved a pure neutral gray you can warm, cool, lighten, darken, or move in the direction of any hue by simply adding other hues. Add a little blue and the pool turns cooler and bluer. Add yellow and the pool is warmer and more yellow. To darken the pool, add more pigment. To lighten, add water. Now do a painting that explores the subtleties and contrasts of these neutrals. Remember, to really turn on the brilliance of these colors you must save room for the contrasting intensities.

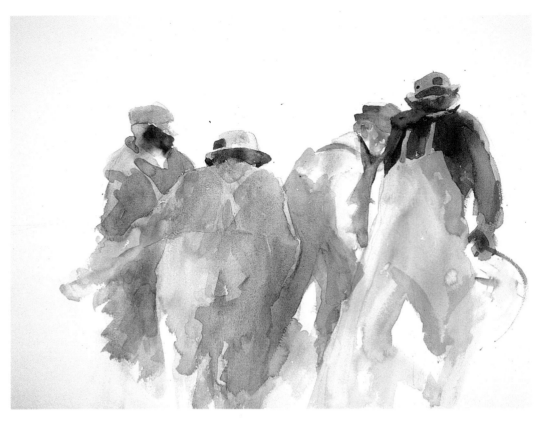

Oyster Dredgers
22" × 30"

I painted this to illustrate how a number of objects can be joined together as a single shape. Instead of painting four fishermen, I made a shape that was dominated by the color yellow — a near-neutral intensity of a middle value. The figure to the right contrasts in color intensity and value.

Woodbine, Maryland
20" × 26"

The warm intense hues of the sky, contrasting with the cool, more neutral colors of the land mass, were the reason to paint. Once the concept is clear, the application of pigments is easy. Big thoughts and big shapes lead to simple and effective paintings.

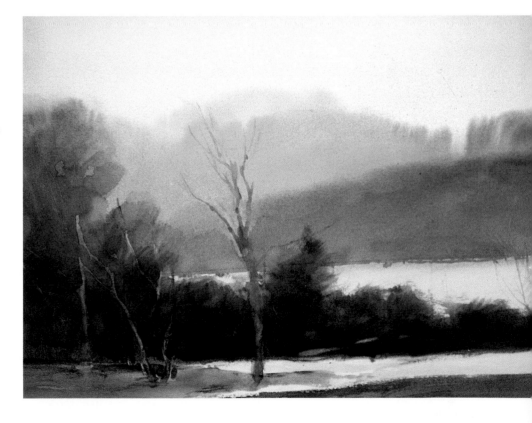

Temperature Shapes

It is possible to make shapes that are dominated by temperature. Having committed to a temperature dominance allows for spectral variations from at least half the color wheel as well as a wide range of values.

The Contrasting Elements

Each of the dominances I have described has been used to ensure unity. For each, there is an opposite element which creates the visual excitement. So, if your painting is dominated with neutrals you will use pure colors, in smaller amounts, to enrich and enliven the overall effect. If the dominance is pure, the contrast will be neutral.

Practical Application

The subject is a landscape consisting of three well-designed shapes, of varying sizes, representing sky, field and distant mountains. I decide that the sky will be the lightest value shape. By keeping the value contrasts to a minimum I ensure the unity of the shape. If I also limit the color contrasts of this shape I further guarantee the unity of the shape. The problem with this approach is that I have made a very boring sky that lacks value and color contrast. Solution? Keep the values close and change color. I promise you that if you keep the value contrasts close, you can change colors with every brush stroke. Color changes should include not just hue changes but changes in intensity and temperature and *slight* value changes. Follow this same approach for the field and mountain shapes, designating the field as middle value and the mountains as dark value. The result will be a painting that has *unity* because of the close value organization and *variety* from color changes.

Let's do the same subject with a premium on value contrast. Now instead of a painting divided into light, middle and dark value shapes, we have a painting organized by color shapes. The sky is orange, the mountains green and the field purple. Each shape maintains its integrity, identity and unity because of the predominance of a color. As color contrast is limited, you are free to exaggerate value contrast.

Think of the painters who have the greatest value contrast in their work, then judge whether they are not also the painters with the least color contrast. The last of Andrew Wyeth's watercolors I saw were done with raw sienna and India ink. For those who relish strong value contrasts, color is an unnecessary distraction.

In the illustration above, I used only oranges, greens and purples in their respective shapes for purposes of making a point. It is not necessary to limit the color range to one color. Dominance of color does not mean only one color. To achieve dominance is to have a lot of one color or color quality played against a little of another color or color quality (color quality referring to intensity, value or temperature).

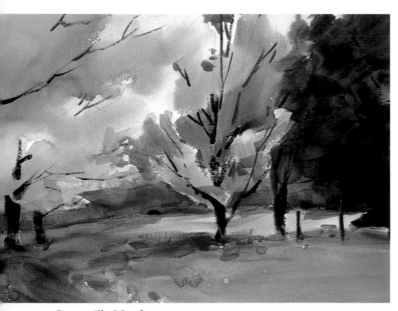

Greenville Meadow
20" × 26"

Think big! Just as paintings can be designed around big value shapes, they can also be organized with temperature shapes. This painting was done to express fall in a town in New York. I did not want to make the maple tree bright and all else neutral in color intensity. My option was to make the tree hot and everything else cooler.

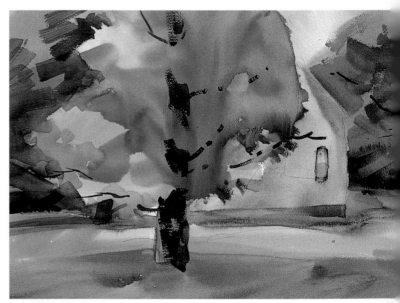

Greenville Meadow 2
20" × 26"

Same day, same place, same approach, different outcome. This maple offered the opportunity to play the warm temperature of the foliage against the complementary, cool and slightly neutral blue of the shed. The warm streak of sunlit lawn created a different design pattern than did the two trees in the previous painting.

DEMONSTRATION: *Creating Unity With Dominance of Color*

Step 1
To ensure a big shape, I begin by outlining the entire subject as one shape. A few lines are added to subdivide the big shape into some secondary shapes. I indicate the roof line of the buildings, the small boat in front, and a line which shows the waterline of the large boat.

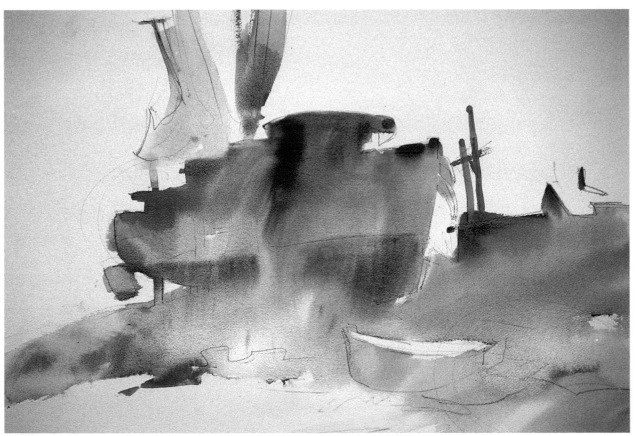

Step 2
I immediately establish the relationship of warm to cool. My choice is dominance of warm with contrasts of cool.

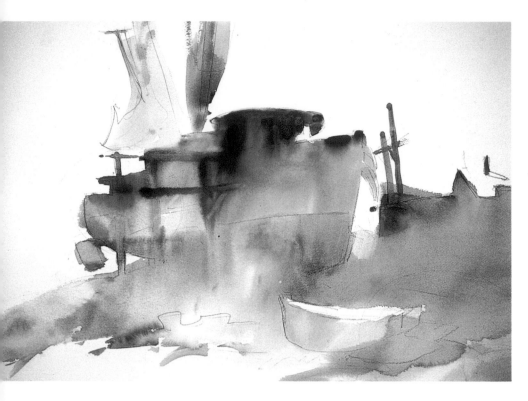

Step 3

I cool and neutralize somewhat the right side of the shape to place emphasis on the bow of the large boat. This light value wash of blue starts at the paint line of the boat and extends into the building. Some of the scaffolding begins to appear when this wash is added. I suggest just enough of the top portion of the scaffolding to show it exists, but not so much as to destroy the big shape.

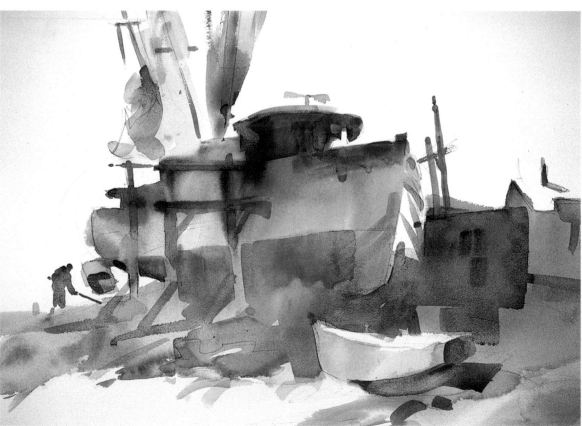

Step 4

Warm glazes are applied to describe the shaded side of the shacks and the bow of the small boat. Warm washes support the warm temperature dominance. Think what would happen if I used cool washes.

Morehead Marina
20" × 26"

Details are added more for information than good painting. Often, the last step may not be the best. Don't allow the subject matter to be more important than the painting.

Remember:

- Of all the principles of design, unity is the most essential.

- Unity is achieved through dominance.

- By establishing big shapes of color, dominance is guaranteed.

- Color dominance can be made with hue (change value, not color), value (change color, not value) and intensity.

- Shapes can be unified by a dominance of intensity, temperature or hue.

- Use big shapes, big ideas and big expectations.

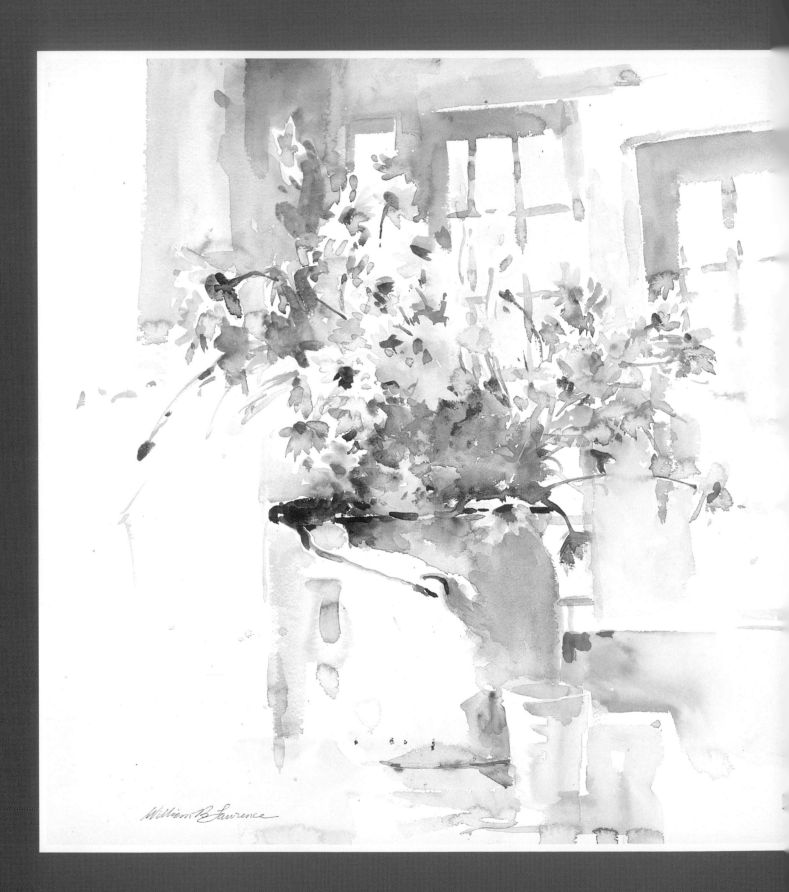

Chapter Ten

DESIGNING WITH LIGHT: FOUR DEMONSTRATIONS

DEMONSTRATION: *Capturing the Light at a Specific Time of Day*

Step 1

While waiting for my daughter to finish her ballet class I observed the last warm light of a November evening. The first job is to identify the big shapes of the street, buildings and automobiles. While these objects are not the purpose of the painting, they are the foil which frames the warm yellow light on the distant facade. Even the figures must be kept quiet so as not to compete with my goal.

Step 2

I begin by painting the sky a tint of cobalt blue and a touch of Winsor blue. While the sky is wet, I paint the pure yellow of the sunlit portion of the distant building. By keeping these two shapes of the same value and intensity I set the stage for the more neutral colors to come. Working with great haste I cover the entire area of the buildings, street and cars with glazes of cobalt blue, permanent rose, and touches of new gamboge. Combining these triads, close in value but slightly darker than the target area, ensures neutral color intensity.

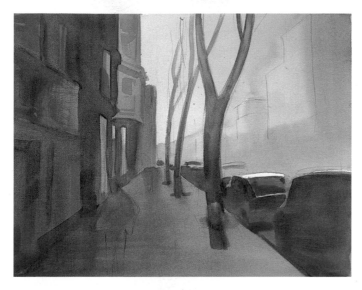

Step 3
To create the effect of reflected light on the building to the left, I paint in some darks — being careful not to make them too dark. The automobiles and trees are painted as one shape with little regard for details.

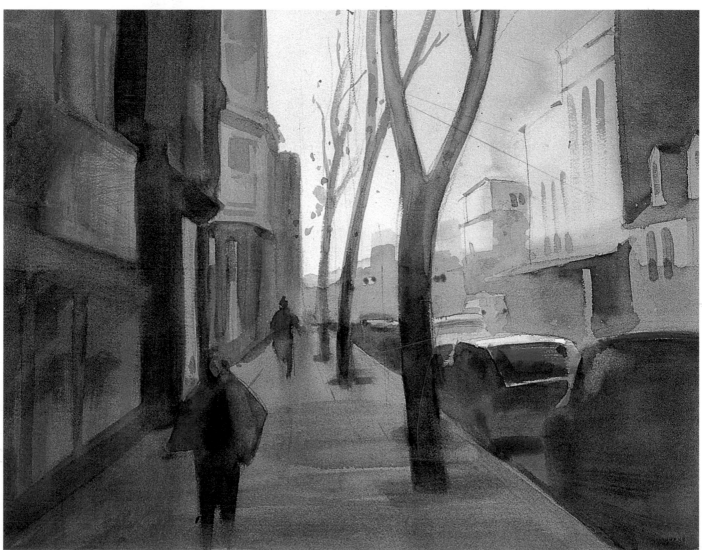

Evening Wait at the Ballet School
20″ × 26″

The figures walking are on their way to the Frederick School of Classical Ballet. They might well be the subject of another painting, but this painting is about a particular light at a specific time of the day. It is because I kept this goal clear that the painting is successful.

DEMONSTRATION: *Developing a Harmony of Color*

Step 1

A student (John) stood outside the studio at Springmaid Beach. The sun hitting the back of his yellow shirt inspired this painting. John posed for a few minutes while I drew his shape and the shape of shade.

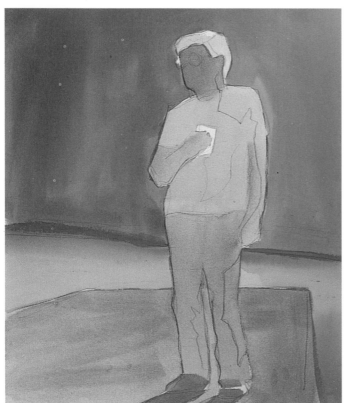

Step 2

The first washes identify the lightest values of local color. The yellow of the shirt is of prime importance and all other colors are reduced in intensity relative to the bright yellow.

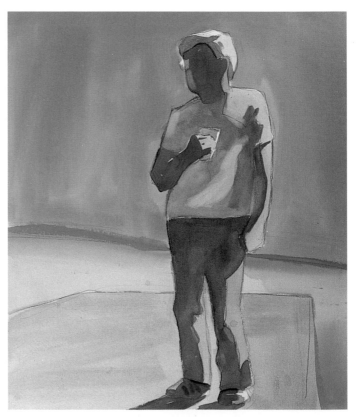

Step 3

Next I paint the shape of shade. Values are painted accurately and with consistency. The shirt in shadow is not painted brown, which would negate the yellow shirt focal point, but a darker, brilliant orange. I proceed with other shadow shapes, being careful to keep color more neutral than the shirt.

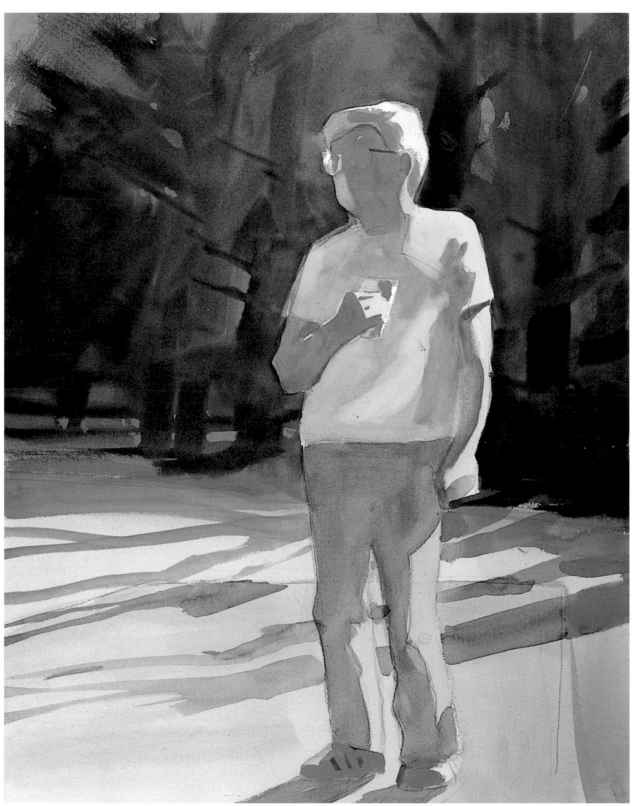

Yankee Coffee Break
26" × 20"

To illuminate the figure, darker cooler colors surround him. There is only a suggestion of trunks and foliage so as not to detract from John. Shadows are cast across the lawn and patio as a transition from the dark woods to the sunlit foreground.

DEMONSTRATION: *Painting the Light—Not the Place*

Step 1
This collection of buildings is next to my studio. On an August day only the shapes of the roofs are made visible by the strong overhead light. I draw the shapes of the buildings only as a guide of the placement of the roofs.

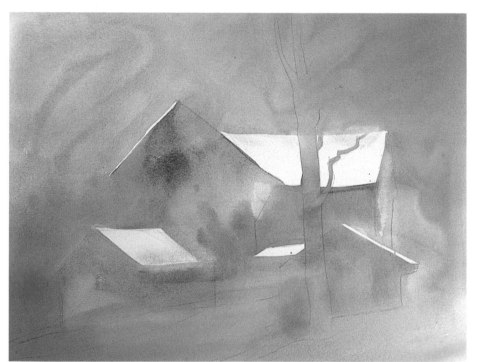

Step 2
I begin by running warm washes over cool washes over everything but the roofs. The first washes are cobalt blue followed by washes of new gamboge and Indian yellow. By working back and forth with these colors, I establish the old farmhouse as slightly more important than the outbuildings.

Step 3

I could stop at this point, but the effect of strong light is missing. The house and outbuildings are darkened with glazes of permanent rose and new gamboge.

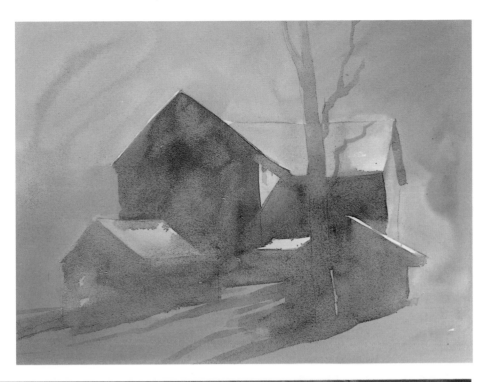

August Light
22" × 30"

I wet the forest shape that surrounds the house and add a glaze of blues, yellows and reds to darken and neutralize. I have painted the light that falls on these shapes numerous times but have never done a painting of the houses. I hope by this point in this book you know what I mean.

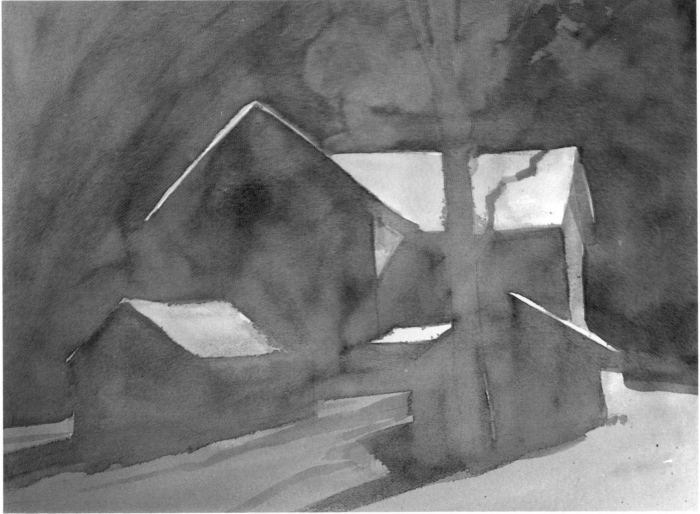

DEMONSTRATION: *Catching a Subject's Luminosity*

Step 1

Most of the paintings in this book are examples of subjects illuminated by an outside light source. This painting, *Ballet Roses*, demonstrates a light that appears to originate from within the subject, having illumination. I begin by carefully arranging the roses in an interesting pattern. The table, leaves and background all must be subordinate to the glowing quality of the roses.

Step 2

Permanent rose and red rose deep are applied to the roses. While they are still wet, to ensure soft edges on the flowers, I cover the rest of the page with phthalo green. A glaze of red rose deep is quickly added to neutralize the green. The table and the portion of the table seen through the vase are painted with a neutral mixture of new gamboge, permanent rose and cobalt blue. The initial covering of the paper is done at breakneck speed, but now I can work more slowly and deliberately.

Step 3 (left)

Every application of color is related to the pure color of the roses to capture their luminosity. The value of the leaves is slightly darker and more neutral than the background. The base color in the leaves is viridian green. Cobalt blue and permanent rose describe the patterns on the vase. Pure red rose deep gives minimal form description to the roses. Too much detail would diminish the desired color effect.

Ballet Roses
20″ × 26″

I darkened the table to reduce its importance and added a few details. My wife and I gave these roses to our daughter after her performance in the *Nutcracker*. It was not the roses that prompted this painting but a father's pride. Without emotional involvement, painting is a hollow exercise in moving your hand.

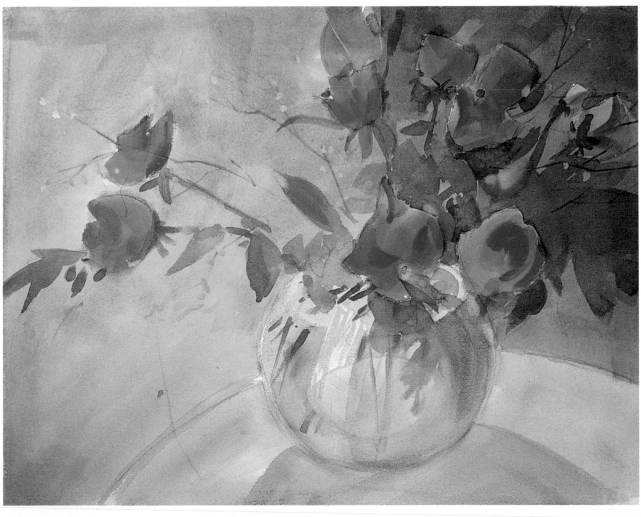

CONCLUSION

I wish I had written this book ten years ago. It most certainly would have been better. Ten years ago I knew a heck of a lot more than I do today. Just imagine how great it would have been had I written this book twenty years ago! I feel fortunate that North Light Books asked me to share my thoughts and approaches at this time. Ten years from now I probably won't be able to say *anything* with certainty. I just recently saw a sweatshirt with a quote attributed to Degas that read, "Painting is so easy when you don't know, and so difficult when you do." I ask that you not hold me totally accountable for what I have written at this time, for most certainly my views will continue to change as my knowledge grows.

There is nothing that I can declare with complete certainty. It is precisely the uncertainty of art that makes painting so appealing to me. I feel sorry for those who have reached a point in their artistic development where they are satisfied. Satisfaction is arrested development.

If what I have shared through this book helps you insert a few pieces into the puzzle we call painting in watercolor, my efforts are well rewarded. Nothing can be more interesting, frustrating or rewarding than the pursuit of a craft that has infinite possibilities. Learn from those who have more experience, but always trust your instincts. Never be satisfied with adequate work or fail to recognize your successes. Above all, enjoy the search and know that there are no absolutes in art.

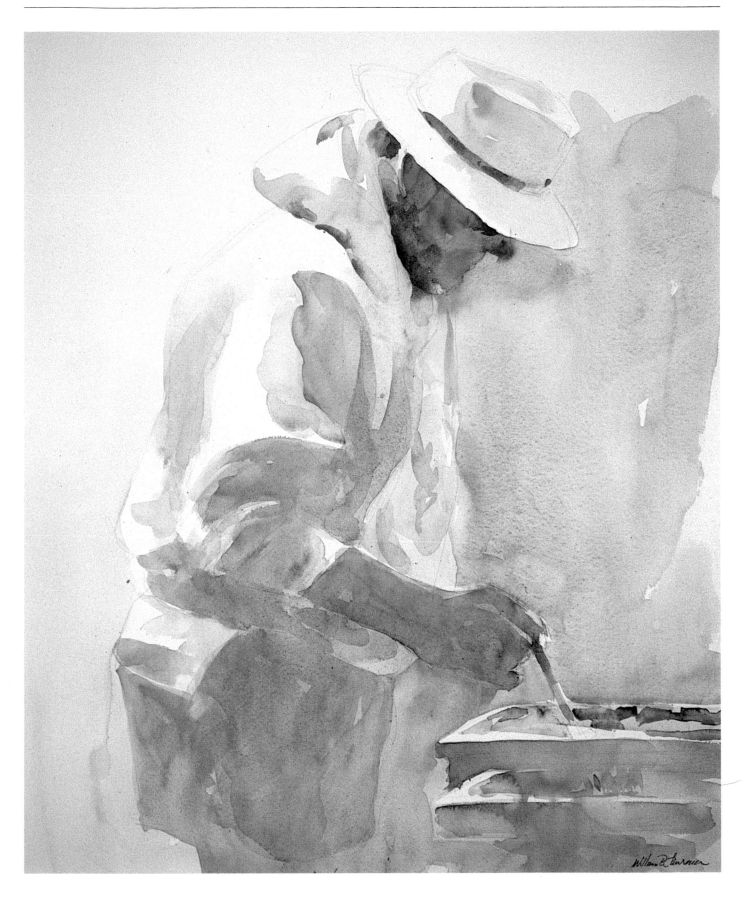

INDEX

More Great Books for Beautiful Watercolors!

Painting Watercolor Portraits—Create portraits alive with emotion, personality and expression! Popular artist Al Stine shows you how to paint fresh and colorful portraits with all the right details—facial features, skin tones, highlights and more. *#30848/$27.99/128 pages/210 color illus.*

Step-By-Step Guide to Painting Realistic Watercolors—Now even the beginning artist can create beautiful paintings to be proud of! Full-color illustrations lead you step by step through 10 projects featuring popular subjects—roses, fruit, autumn leaves and more. *#30901/$27.99/128 pages/230 color illus.*

Painting Greeting Cards in Watercolor—Create delicate, transparent colors and exquisite detail with 35 quick, fun and easy watercolor projects. You'll use these step-by-step miniature works for greeting cards, framed art, postcards, gifts and more! *#30871/$22.99/128 pages/349 color illus./paperback*

The North Light Illustrated Book of Watercolor Techniques—Master the medium of watercolor with this fun-to-use, comprehensive guide to over 35 painting techniques—from basic washes to masking and stippling. *#30875/$29.99/144 pages/500 color illus.*

Capturing Light in Watercolor—Evoke the glorious "glow" of light in your watercolor subjects! You'll learn this secret as you follow step-by-step instruction demonstrated on a broad range of subjects—from sun-drenched florals, to light-filled interiors, to dramatic still lifes. *#30839/$27.99/128 pages/182 color illus.*

Creative Light and Color Techniques in Watercolor—Capture vibrant color and light in your works with easy-to-follow instruction and detailed demonstrations. Over 300 illustrations reveal inspiring techniques for flowers, still lifes, portraits and more. *#30877/$21.99/128 pages/325 color illus./paperback*

Watercolorist's Guide to Mixing Colors—Say goodbye to dull, muddled colors, wasted paint and ruined paintings! With this handy reference you'll choose and mix the right colors with confidence and success every time. *#30906/$27.99/128 pages/140 color illus.*

Splash 4: The Splendor of Light—Discover a brilliant celebration of light that's sure to inspire! This innovative collection contains over 120 full-color reproductions of today's best watercolor paintings, along with the artists' thoughts behind these incredible works. *#30809/$29.99/144 pages/124 color illus.*

Learn Watercolor the Edgar Whitney Way—Learn watercolor principles from a master! This one-of-a-kind book compiles teachings and paintings by Whitney and 15 of his now-famous students, plus comprehensive instruction—including his famed "tools and rules" approach to design. *#30927/$22.99/144 pages/130 color illus./paperback*

How to Get Started Selling Your Art—Turn your art into a satisfying and profitable career with this guide for artists who want to make a living from their work. You'll explore various sales venues—including inexpensive home exhibits, mall shows and galleries. Plus, you'll find valuable advice in the form of marketing strategies and success stories from other artists. *#30814/$17.99/128 pages/paperback*

Painting Watercolors on Location With Tom Hill—Transform everyday scenes into exciting watercolor compositions with the guidance of master watercolorist Tom Hill. You'll work your way through 11 on-location projects using subjects ranging from a midwest farmhouse to the Greek island of Santorini. *#30810/$27.99/128 pages/265 color illus.*

1997 Artist's & Graphic Designer's Market: Where & How to Sell Your Illustration, Fine Art, Graphic Design & Cartoons—Your library isn't complete without this thoroughly updated marketing tool for artists and graphic designers. The latest edition has 2,500 listings (and 600 are new!)—including such markets as greeting card companies, galleries, publishers and syndicates. You'll also find helpful advice on selling and showing your work from art and design professionals, plus listings of art reps, artists organizations and much more! *#10459/$24.99/712 pages*

Basic People Painting Techniques in Watercolor—Create realistic paintings of men, women and children of all ages as you learn from the demonstrations and techniques of 11 outstanding artists. You'll discover essential information about materials, color and design, as well as how to take advantage of watercolor's special properties when rendering the human form. *#30756/$17.99/128 pages/275+ color illus./paperback*

Becoming a Successful Artist—Turn your dreams of making a career from your art into reality! Twenty-one successful painters—including Zoltan Szabo, Tom Hill, Charles Sovek and Nita Engle—share their stories and offer advice on everything from developing a unique style, to pricing work, to finding the right gallery. *#30850/$24.99/144 pages/145 color illus./paperback*

In Watercolor Series—Discover the best in watercolor from around the world with this inspirational series that showcases works from over 5,000 watercolor artists. Each minibook is 96 pages long with 100 color illustrations.

> **People**—*#30795/$12.99*
>
> **Flowers**—*#30797/$12.99*
>
> **Places**—*#30796/$12.99*
>
> **Abstracts**—*#30798/$12.99*

Watercolor: You Can Do It!—Had enough of trial and error? Then let this skilled teacher's wonderful step-by-step demonstrations show you techniques it might take years to discover on your own. *#30763/$24.99/176 pages/163 color, 155 b&w illus./paperback*

How to Capture Movement in Your Paintings—Add energy and excitement to your paintings with this valuable guide to the techniques you can use to give your artwork a sense of motion. Using helpful, step-by-step exercises, you'll master techniques such as dynamic composition and directional brushwork to convey movement in human, animal and landscape subjects. *#30811/$27.99/144 pages/350+ color illus.*

Creative Watercolor Painting Techniques—Discover the spontaneity that makes watercolor such a beautiful medium with this hands-on reference guide. Step-by-step demonstrations illustrate basic principles and techniques while sidebars offer helpful advice to get you painting right away! *#30774/$21.99/128 pages/342 color illus./paperback*

Creative Watercolor: The Step-by-Step Guide and Showcase—Uncover the innovative techniques of accomplished artists as you get an inside look at the unending possibilities of watercolor. You'll explore a wide spectrum of nontraditional techniques while you study step-by-step projects, full-color galleries of finished work, technical advice on creating professional looking watercolors and more. *#30786/$29.99/144 pages/300 color illus.*